DEDICATED TO

HANNI [and] H. P. K., JR.

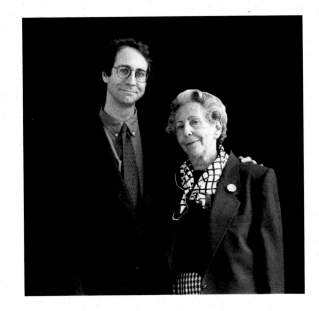

EDITOR AND TEACHER **MARTINA KUONI** [*and*] **JOHANNES KUONI**
New York
1990

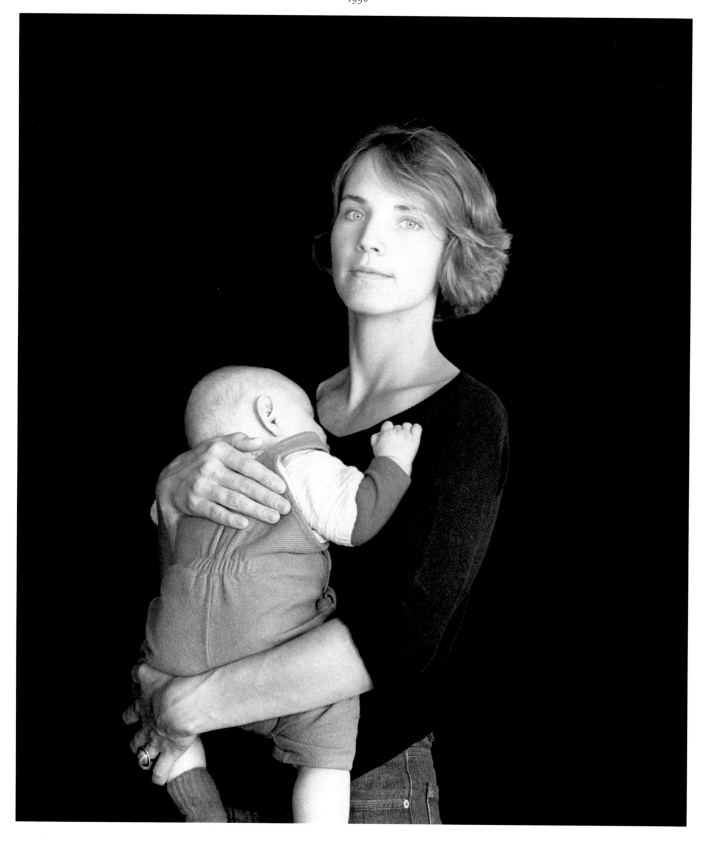

PHOTOGRAPHS BY MARIANA COOK

INTRODUCTION BY ISABEL ALLENDE

MOTHERS [and] SONS

IN THEIR OWN WORDS

CHRONICLE BOOKS

SAN FRANCISCO

SPECIAL THANKS GO TO ERIKA ELLIS
FOR HER DEVOTED ASSISTANCE.

COPYRIGHT © 1996 BY MARIANA COOK | INTRODUCTION © 1996 BY ISABEL ALLENDE
PRINTED IN HONG KONG

LIBRARY OF CONGRESS
CATALOGING-IN-PUBLICATION DATA:

COOK, MARIANA RUTH.
MOTHERS AND SONS: IN THEIR OWN WORDS | PHOTOGRAPHS BY MARIANA
COOK; INTRODUCTION BY ISABEL ALLENDE
 132P 246 X 305 CM
 INCLUDES INDEX.
 ISBN 0-8118-1194-8. – ISBN 0-8118-1170-0 [PBK]
 1. MOTHERS AND SONS – PICTORIAL WORKS. I. TITLE
HQ755.85.C664 1996
306.874'3 – DC20 95-30152
 CIP

DESIGNED BY CONCRETE, CHICAGO

DISTRIBUTED IN CANADA BY
RAINCOAST BOOKS
8680 CAMBIE STREET
VANCOUVER, B.C. V6P 6M9

3 4 5 6 7 8 9 10

CHRONICLE BOOKS
85 SECOND STREET
SAN FRANCISCO, CA 94105

WWW.CHRONICLEBOOKS.COM

CONTENTS

6 INTRODUCTION BY ISABEL ALLENDE

11 PORTRAITS

129 LIST OF PORTRAITS

WRITER **ISABEL ALLENDE** [*and*] **NICOLÁS FRIAS** STUDENT AND FATHER

Sausalito, California
1994

I had never talked about my relationship with my son until Mariana Cook invited us to pose for her and later asked me to write this introduction. Actually, I had never given it much thought either, Nicolás is like an extension of myself; our mutual acceptance is an organic bond that is not questioned, therefore it seems useless to analyze it. When Mariana proposed the photo session, I approached my son cautiously because he abhors publicity, but to my surprise he accepted immediately. I am glad he did. Mariana's photograph is now on the wall over my desk in a place of honor, as a perfect testimony of the complicated and unique kind of love that links a woman with her son. I look at it every day with gratitude and wonder. How could I possibly produce this man? He is so different from me and yet so familiar...I would not be me without him, and he would be someone else without me.

My children, Paula and Nicolás, determined my life. Since the days my pregnancies were announced in dreams before any physical symptoms appeared, I have never considered myself an individual, but part of an inseparable trio. Although I belong to the lucky generation of the pill, it never occurred to me that motherhood was optional; I assumed it with the stern determination of a true fanatic. Yes, I have two children, but one is dead. My daughter's death is a tragic inconvenience, but it has not modified the essence of our relationship. We are still as close as we were when she was alive. Although I can't call her on the phone and she would not be available for a photograph if someone came up with the idea of a book about mothers and daughters, Paula is always with me, like a gentle ghost. Her death has made Nicolás' presence even more precious to me. He lives a few blocks away from my office, we are constantly in touch, and we help each other in important matters as well as in the daily details. In spite of this proximity we manage to be emotionally sane and even tease each other with a touch of cruelty. I am certain that he does not suffer from an Oedipus complex—he is much too cool for that and I don't deserve it.

Nicolás made a difficult entry into the world after two days of labor during which I had the feeling of falling into an abyss, gaining speed with every second, until a final tumultuous explosion burst me open and pushed the baby from my body with uncontrollable force. I had experienced nothing like that when Paula was born three years before because she was a clean cesarean. There was nothing romantic about my son's birth, only effort and loneliness. I thought childbirth was a strictly private ordeal, like death, and on the other hand, at the time Chilean fathers did not participate in the process of childbirth and often they didn't participate much in the task of raising their offspring, either. Later I learned that in some more developed societies you could deliver your baby with your husband and friends, good music, marijuana, and a photographer! Anyhow, my former husband was not the ideal companion for such events, as he fainted even at the sight of a needle. Nicolás was born without any hair, with a horn on his forehead, and a purple arm, like a monstrous creature from another planet, but the doctor assured me that he was almost human. The unicorn was produced by the forceps used in labor, and in a few months the blue pigment faded from his arm. I remember him always bald, so now I am a little startled when I see that he has thick eyebrows and is growing a ponytail. From the beginning, Paula acted like a fairy godmother to her ugly little brother. The two shared a tiny room with storybook characters painted on the walls. At night a sinister dragon—a deceitful animal that turned into a sturdy cherry tree during the day—waved its menacing claws in the window. With great difficulty Paula would take the baby out of his crib and drag him by a foot to my bed. She couldn't lift him but neither could she leave him behind at the mercy of the beast in the garden. Later, when Nicolás learned the fundamentals of fear, he slept with a hammer beneath his pillow to defend his sister. These unfortunate children were victims of my storytelling vice: they grew up listening to long, spooky tales that filled their days with wonder and their nights with terror. They survived, however, just as they survived the measles, Chilean drinking water, thirty-seven minor car accidents and two nearly fatal ones [I am not a good driver], and the adventures of my rather unusual fate. When planning this introduction I reviewed our past and

decided it was time to apologize to my son for some of the pain I may have inflicted upon him. He looked at me with a puzzled expression; *What are you talking about, Mom, there never was any pain, just embarrassment!* he replied.

The main traits of Nicolás' character were present from the start: he is so calm, unassuming, discreet, and pragmatic [and also tall, slim, and handsome] that he obviously doesn't have any of my genes. He is a biological accident. Due to the fact that we are so different, we like each other a lot. I am sure that he considers me slightly retarded, but is too polite to express it. I, on the other hand, know that he is almost a genius but have never told him so; in our family we don't go around flattering each other. The only rough period in our lives together was when he was in his teens. We had fled from a dictatorship in Chile and were struggling as new immigrants in Venezuela with no money, no friends, not even proper visas. Unfortunately, there was no way to preserve my children from those hardships; they had to follow the destinies of their parents. It took several years for Paula and Nicolás to adapt. For a long time they begged me to go back to our country. We could not return, though. By then their lovely grandmother had died of sorrow—the pain of the separation from her grandchildren was too much for her—and their grandfather had become a demented old man. Our friends and relatives were scattered around the world, in prison, or dead and there was no place for us in our homeland.

In Caracas we lived in the noisiest and most crowded district; for the children used to the freedom of their quiet neighborhood in Santiago, it was hell. Nicolás behaved like a bandit, his grades were a disaster and he became suspiciously accident-prone. He would invent all sorts of dangerous games and as a result walked around with bandages from head to foot. He discovered the joy of using his slingshot to catapult eggs from our window on the fifth floor. Despite the fact that we were consuming ninety eggs a week, and the wall of the building opposite us was one giant omelet baked hard by the tropical sun, I refused to accept the neighbors' accusations—until the day one of the projectiles hit a senator, who happened to be passing beneath our balcony, on the head. We were on the verge of being expelled from the country by that infuriated statesman.

In the turbulence of my youth and the efforts to succeed in a foreign land, I paid little attention to my children, trusting always that they would overcome the difficulties of growing up. I had this idea that if you give them unconditional love and clear boundaries, they would be able to learn from mere observation and osmosis and everything would be just fine. In the process, however, they must have felt somewhat insecure. I didn't notice how they left their childhood behind and one day they woke up, transformed into a pair of slender young people with a determined expression in their dark eyes. The complicity of their childhood had developed a solid friendship that bound them together till Paula's last day of life. In those years Nicolás grew a span, and materialized one day with his pants legs at mid-thigh and his shirt bursting over new muscles. He was climbing mountains, diving in the ocean to photograph sharks, and making secret plans to scale the tallest skyscraper in the city without ropes. Those were not the only reasons for me to worry. One evening I came home and found the house dark and apparently empty. I could see light at the end of the hall, where his room was, and so I walked toward it calling him. Suddenly in the frame of the door I saw my son with a rope around his neck; there was enough light for me to see his tongue hanging out and his eyes rolled back. I dropped to the floor, frozen and rigid like a corpse. When Nicolás saw my reaction, he unbuckled the harness from which he was so skillfully suspended and rushed to comfort me, showering his poor mother with repentant kisses and swearing he would never do it again. His good intentions lasted about two weeks, until he discovered a way to submerse himself in the bathtub and breathe through a straw so I would think he had drowned. According to Paula's textbooks—she was studying psychology—these heart-stopping jokes were motivated by unexpressed anger, but after much thought we concluded that sometimes the manuals are mistaken. Nicolás was not a suicidal maniac, and his affection for me was obvious; he just had a weird

sense of humor. Time proved our theory. On his seventeenth birthday, my son put his mountain climbing gear, harpoons for killing sharks, and first aid kit away in the garage, and declared that he had registered at the university to study computers. Eventually he graduated with honors, married a wonderful woman, moved to California, and had three adorable children. Now, when I see him with his serene intellectual expression, a baby in each arm and a toddler tugging at his pant-leg, I ask myself if I didn't dream that hair-raising vision of him swinging from a homemade gallows. Yes, he grew up, however I still consider him the bald infant with the unicorn and purple arm whose back I used to scratch to put to sleep.

In 1992, Paula died of a rare disease after being in a coma for a long, painful year. Nicolás was present at each stage of that unforgettable ordeal. He took care of his sister with the same courage and love that he bestowed on her when the dragon of the garden threatened them in the nights of their childhood. On 6 December Paula slowly drifted away. Nicolás and I cuddled her during her last hours in this world, then at dawn, we ushered her peacefully into death. A few days later we went together to a forest of tall redwoods and on a crisp afternoon scattered her ashes in a stream. When the last particles of white dust were carried away by the water, I turned to look at my son and through a veil of tears I saw that he had suddenly grown six feet tall, had a stern jaw of a fighter and the soft eyes of an old soul, and stood at my side like a mature man. He was wrapping me in his arms and no words were needed. Maybe that is why I like Mariana Cook's photograph so much. When she asked us to pose for her, my son adopted immediately the same protective gesture of that day in the forest when we bid Paula farewell. Looking at this photograph I realized that Nicolás has been holding me in his arms much longer than I ever held him....

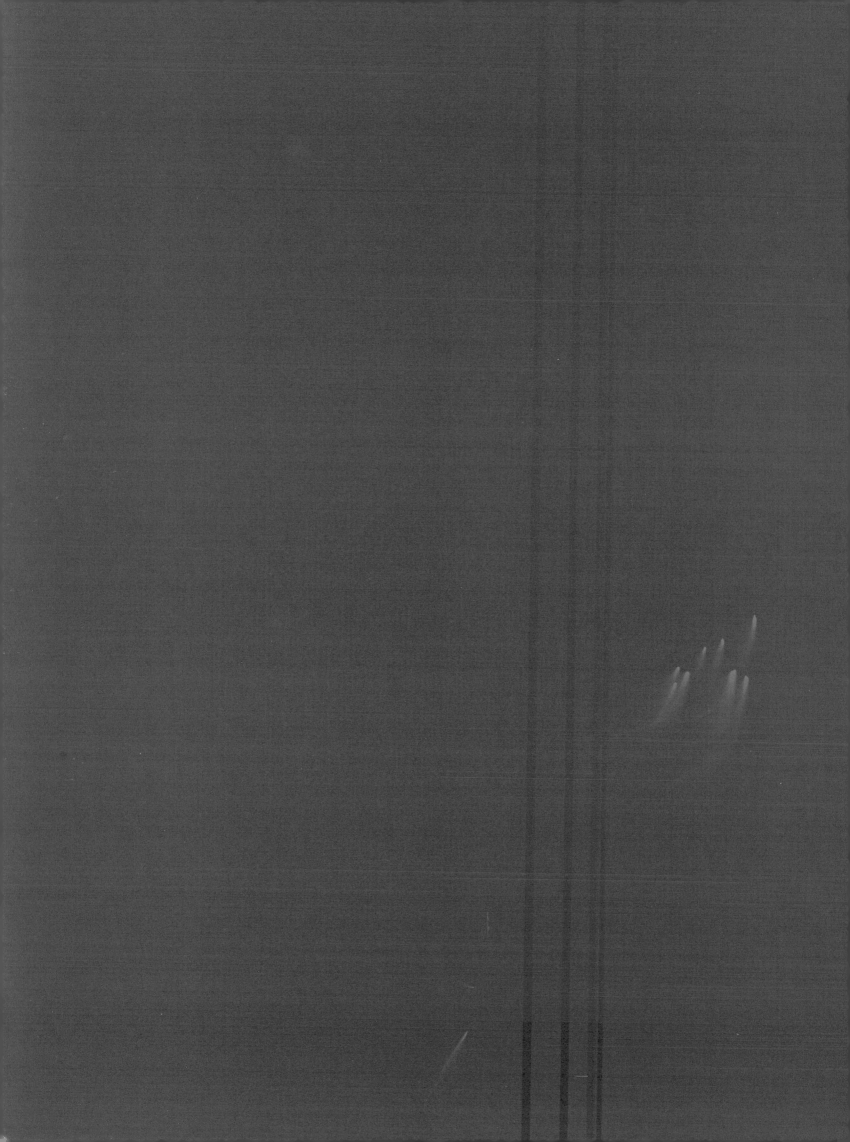

WRITER JAMAICA KINCAID [*and*] HAROLD SHAWN

North Bennington, Vermont
1995

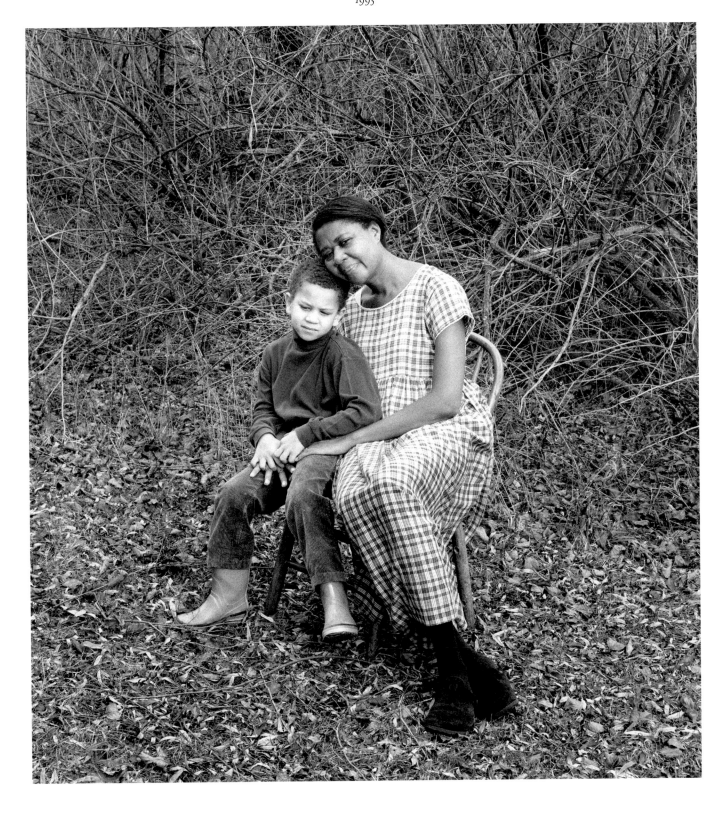

FASHION DESIGNER **SONIA RYKIEL** [*and*] **JEAN-PHILIPPE RYKIEL** MUSICIAN
Paris
1994

SONIA RYKIEL Mother-Son, a funny relationship.
Difficult contacts, mutual respect.
 He is a musician. I, a maker—on that level it works.
 Endless conversations about invention, pain, beauty,
creativity. More complicated conversations about life,
how to live, but a real complicity of hearts.

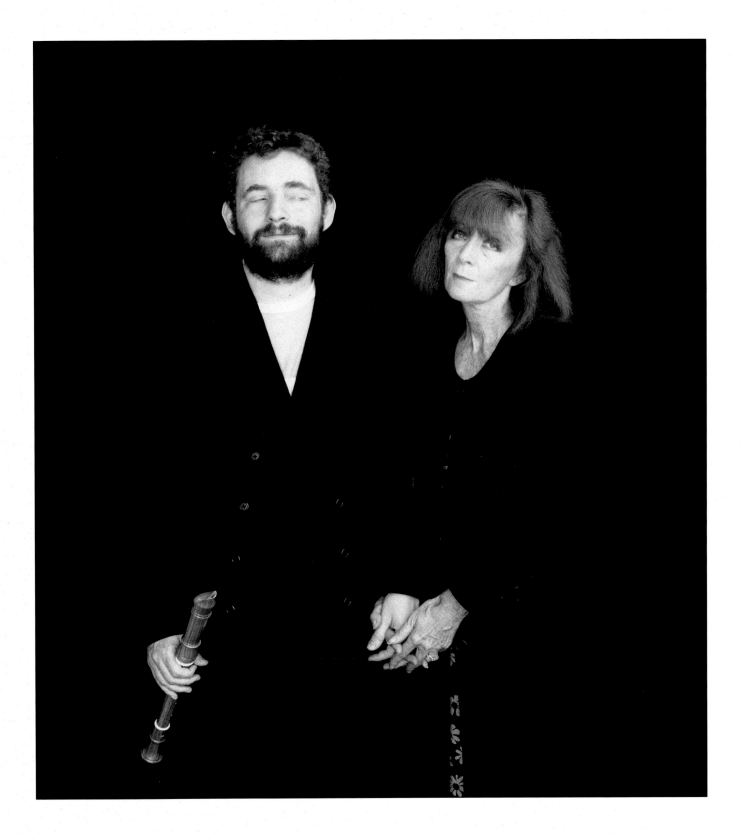

AVID READER **PAULINE EDELSTEIN** [*and*] **BURTON EDELSTEIN** BUSINESSMAN

San Francisco

1993

BURTON EDELSTEIN My mother was born in Russia in the town of Domachevo on 1 June 1899; immigrated to the United States in the summer of 1908. I was born in San Francisco, California, on October 16, 1925.

I am convinced that all learning derives from experience and example, never by direct instruction. My mother, being a hands-on parent, has always believed in giving instruction on every phase of my life, and even now at the age of ninety-four is never reticent in announcing my failures. Right or wrong, I respect her energetic commitment. While she is completely loyal to her Jewish faith, her absolute moral character, her sense of responsibility to her family and people, and her constant search for knowledge and understanding go far beyond religion's demands.

Circumstances impelled my moving abroad some seventeen years ago. Since then we have conducted a steady correspondence and I make a summer and winter visit. Now living in a home for the aged, with limited eyesight forcing her to subscribe to Books on Tape, she has discussed with me on my last two visits a biography of Thomas Jefferson, a book on astronomy, a biography of Charles Dickens, a work on the *Zohar*, a study of the life of Hirohito, a book by Sidney Hook, and related to me her book-review group's current reading of Arthur Schlesinger's *The Disuniting of America*.

BOOKBINDER ROMILLY SAUMAREZ SMITH [and] OTTO SAUMAREZ SMITH

London
1993

ROMILLY SAUMAREZ SMITH I asked Otto what he felt about me. He thought for a long minute and said, "I feel you are a very special sort of Mummy. You are not like other Mummies. I love you septillion times."

Otto is my first son. He is brave, beautiful, and hugely imaginative. His mind is full of knights in armor and Lawrence of Arabia and the battles they fight. He plays elaborate, imaginary games, often singing an accompaniment. We talk and talk about many things and he has great understanding and sympathy for one so young.

The photograph says it all really, and my only sadness is that my younger son, Ferdinand, would not be still enough for long enough to be in it too. He is three years old, a little wild and wonderfully loving with auburn curls and a face like a painting by Joshua Reynolds. And I love them both septillion times!

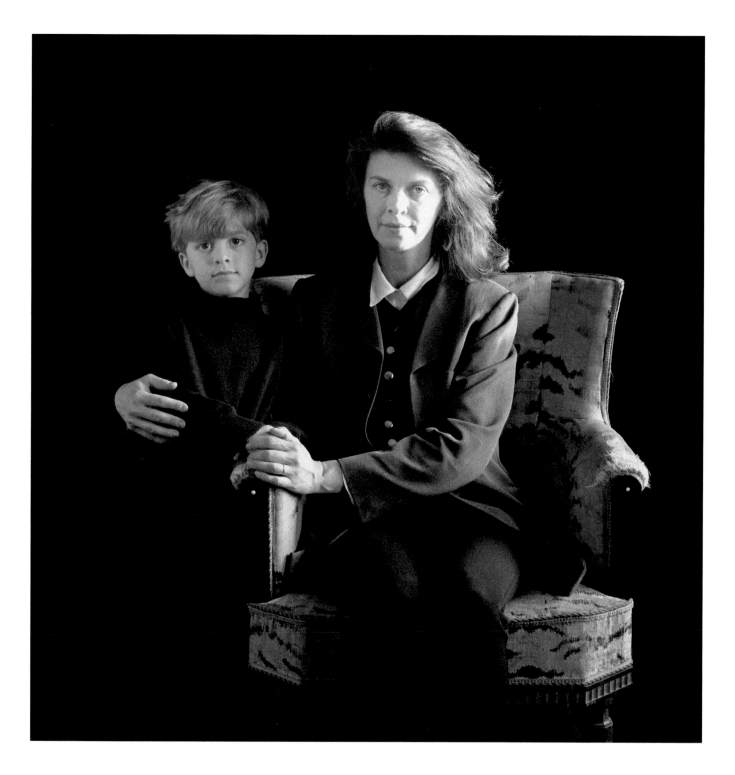

NURSE **SYLVIA IVY BRUDENELL SALMON** [*and*] **COLIN SALMON** ACTOR AND MUSICIAN

London
1993

COLIN SALMON My mother worried about going to Jamaica. At age forty-four she had never been on an airplane. Her fear was not of flying. It came from the reception she thought she might receive. Would it be the same as that given to her husband when he arrived in England 30 years before? Would there be the same cold looks that they had felt as they walked down the street together at the beginning?

How would his family take to her? Would they be proud or politely tolerant? And what would they be like? Always a modest man, my father had told her so little about his family, about the land they owned, about the lifestyle they led.

The idea of being on a beach also held a mixture of exhilaration and dread. Paradise at last—but what about her figure? Her weight had been a battle she had waged physically and mentally. Would her husband feel ashamed? Would all the pretty ladies laugh at her and chase him?

My mother was my confidante and my friend. She shared these thoughts with me before her trip to Jamaica. So I reminded her of her strength and beauty, and of the very special generosity of spirit that people knew her for. "You worked hard and battled against so much and brought us up to be confident, fair people, and you passed on to us the ability to make friends wherever we went. You deserve a trip to paradise," I told her.

It was a perfect holiday. She loved the family and they loved her. She was treated with the utmost respect and, as the guest of honor, was driven to the best restaurants and beautiful beaches. My father, in his modesty, had never really told us how well-to-do his family was, and while my mother was with them, she was treated like a princess. The photos show her surrounded by children listening to her stories and songs, just as we had. The island permeated her soul and freed her spirit. I learned that she skinny-dipped, proudly, in the ocean.

She returned stronger, centered, and at peace. I swear she was taller. She was finally happy with herself, not just a mother proud of her children. The girl was back.

The dynamics of life can be cruel. There will always be mosquitoes in paradise and unfortunately they attacked my mother. She reacted badly to their bites, requiring a stay in hospital immediately on her return home. Medication followed, the effects of which caused a deep depression. The holiday seemed far away.

All of a sudden, small, everyday things became stumbling blocks. When somebody stole her purse and she lost her keys, she was inconsolable. The end result was that on Monday, the 22nd of September 1986, my mother wrote a note telling of her love for and pride in her family, and took her own life.

The coroner's report was not suicide, but an open verdict because of her reaction to the medication. This gave us some peace of mind, but how could we completely recover? My grief was great. Losing my mother was devastating, especially when she was still so young. I hadn't yet had the chance to fulfill the dreams I had shared with her. She never met my wife or saw my children and I would never hear her delight them with stories of me as her little boy, as only a mother can. But I see her in my daughters. Her spirit is everywhere, and she still makes me smile.

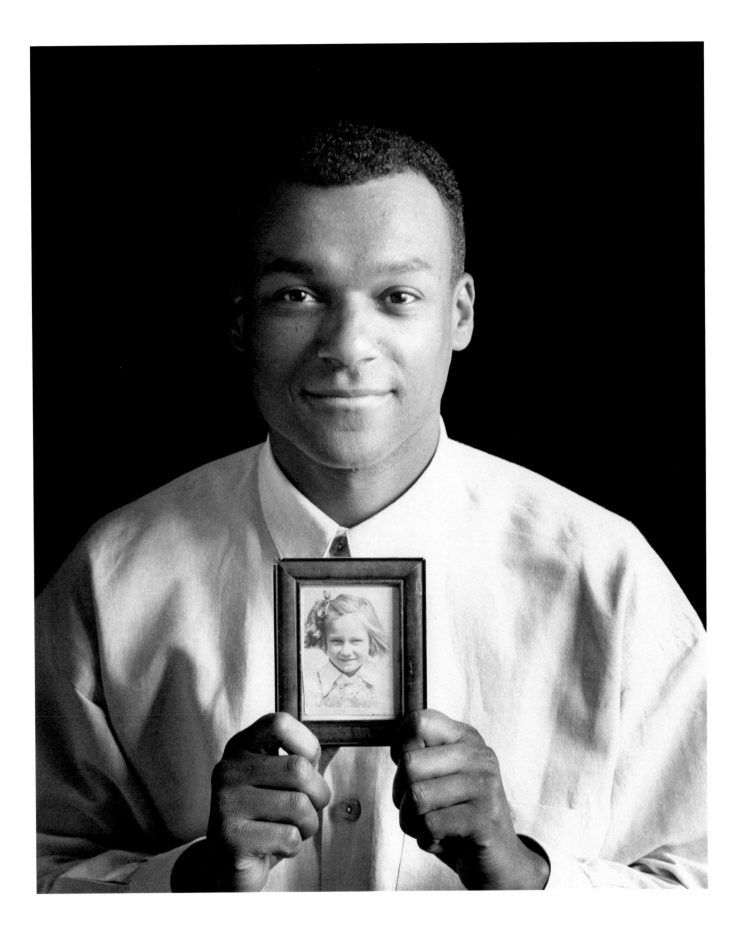

DIPLOMAT **PAMELA HARRIMAN** [*and*] **WINSTON S. CHURCHILL** MEMBER OF PARLIAMENT

Paris
1994

WINSTON S. CHURCHILL By the standards of today, my upbringing was unconventional. I was born at Chequers in Buckinghamshire, the country residence of Britain's prime ministers, on 10 October 1940, just as the Battle of Britain had reached its victorious climax. A German bomb had landed on the lawn outside the house the night before: It was the second bombshell in twenty-five hours.

In common with most of my generation it was to be several years before I came to know my father. Earlier in the war he was posted to North Africa to fight Rommel and later parachuted into Bosnia to fight alongside Marshal Tito and the Yugoslav partisans. The first I knew of this being called "Father" was when a case of green objects called "bananas" arrived from North Africa with love from "Father." Although they were green and hard, my nanny made me eat them. This prejudiced me against bananas for life. Fortunately, any similar feelings about my father were assuaged with the passage of time!

For much of the war, I lived with my mother in a top-floor apartment at 49 Grosvenor Square. It enjoyed a grandstand view over London, especially at night when anti-aircraft guns in nearby Hyde Park pumped tracers into the night sky and blazes from buildings hit by German bombs lit up the city. Whenever the air-raid sirens started their piercing wails, I would be bundled in a blanket and raced down six flights of stairs to the air-raid shelter, where we would be joined by Londoners who dived in for protection on their way back from work or the theater.

PAMELA HARRIMAN At the age of five, Winston realized that his grandfather had a job. After the British elections in 1945, the Churchills had to leave 10 Downing Street almost immediately. They moved temporarily to Claridges Hotel to the penthouse of their friends, the Alexander Kordas. To bring to the apartment a flavor of home, Mrs. Churchill put up many of her husband's paintings on the wall. Young Winston, on his way home from school, stopped off to visit with his grandfather. When he returned later that evening, he greeted me with shining eyes, explaining, "My grandfather is a painter." He had finally discovered something that his grandfather did.

One of my earliest memories is of the incredible warmth of feeling down there, despite the dank coldness of the shelter. There would be sweet, hot tea and biscuits to warm us and, as the bombs crashed overhead, joyful renditions of all the old music hall songs of the day.

As soon as the war was over, my parents divorced. As my late father, Randolph, once remarked, "Ours was a marriage made and broken by Hitler!" Having married within three weeks of their first meeting, which took place just ten days after the outbreak of war, they were soon to be torn apart when my father was posted overseas. It was not long thereafter that my parents' marriage fell apart. Having never known them together, the fact of their divorce made no impression on me or on my life.

Thereafter I spent much of my holidays with my respective grandparents. But, though it may not be fashionable these days to admit it, within the limitations of their own very busy lives, both my parents did their very best to ensure that I had a wonderfully happy and secure childhood. For that, I am most grateful.

In contrast to the rationing and austerity of the wartime years, my memories of the postwar years with my mother, who was by then living in Paris, are of exotic holidays in the south of France and of winter sports in the Alps, skiing and Cresta-riding in St. Moritz. Wherever she went, my mother turned heads and was the center of attention. One evening as a young teenager, newly arrived at boarding school at Eton, one of the senior boys doing his round of the House before lights out demanded: "Who was your red-headed girlfriend you were out with today?" I protested that I had not been out with any girlfriend, only my mother. Refusing to believe me, he went away muttering, "Stunningly beautiful! Stunningly beautiful!"

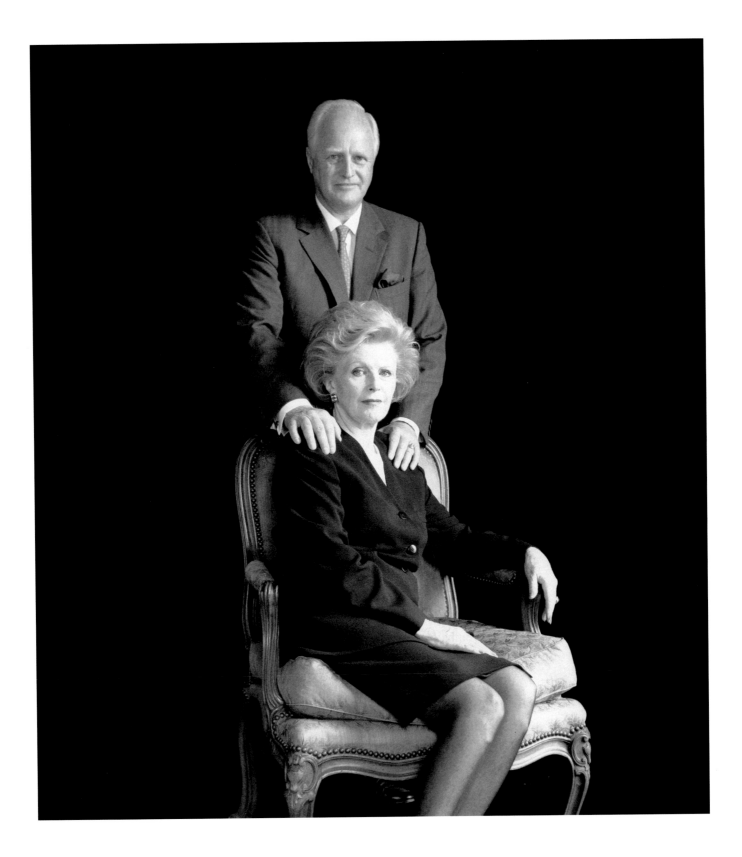

AVID READER **PAULA KISSINGER** [*and*] **HENRY A. KISSINGER** FORMER NATIONAL SECURITY ADVISOR AND SECRETARY OF STATE

Kent, Connecticut
1994

PAULA KISSINGER My relationship to Henry has gone through different stages. In the old world we shared his happy childhood, wonderful vacations in my father's house in the country. We were close as mother and son.

In the new world, the roles changed. In trying times he had become a moral support. He stood by with his advice. He had become my friend. When he went to war, letters were the link to share our loneliness. I wrote every other day and he answered three times a week. When he finally returned and gradually achieved undreamed-of success, I rejoiced with him. The new dignity brought many changes, but it did not change his loyalty.

There were frequent visits at home, duly celebrated. There were glamorous parties, the mother proud on the arm of her son; the opening session of the United Nations, highlighted by his speech; and to crown it all, the visits to the White House to meet the various presidents. I call it the glamour phase.

And now the roles have changed once more. After staying in his and Nancy's house, a paradise in my eyes, sharing his friends, his ideas, his work, he has made life a new experience, and he has become the loving, caring support of his old mother.

HENRY A. KISSINGER One of the great blessings of my life has been that I have had the good fortune to be able to share so much of it with my mother. The happiest times of my childhood were spent at her family's house in Leutershausen, a small village in Franconia. The fields, the trees, and the walks which evoked her own youth forged a sense of continuity at a time when family ties were the refuge from the totalitarian system springing up all around us.

Much has been written about how traumatic a period this was supposed to have been in my life. But in truth, my mother's courage and unfailing good humor shielded us children from much of what was for her and for my father, in fact, traumatic. She saw to it that we had a nearly normal childhood. But, crucially, she also saw to it that our family left Germany before the worst excesses of Nazi tyranny had come to the surface. Much as my mother was tied to her roots, she insisted on wrenching herself into emigration in order to achieve a more hopeful future for her children, even while most of her contemporaries were still hesitating.

Once in America, we lived in extraordinarily close quarters like many millions of immigrants before us; indeed, my brother and I had to sleep in the living room because the extra bedroom was being let. Yet I remember those years not in terms of hardship but of fulfillment as we built a new life, drawing comfort from each other. As she had done in Germany, my mother continued to create an atmosphere of normalcy and good cheer, in addition to which she made our lives easier financially by working at jobs which, in her previous comfortable existence, she could hardly have imagined would be her lot.

Through all this, she was the confidante of her children and the moral support of her family. Inevitably, as I went off to the Army and then to college, that close relationship continued. At every crucial stage of my life I have been lucky to have had my mother at my side, and her encouragement means no less to me now that I have myself joined the ranks of the older generation. As we have both become older, we are in fact spending almost as much time together as we did in those far-off days in her father's village. And my admiration and love for my mother's courage, her sense of humor, and her supreme common sense have only deepened.

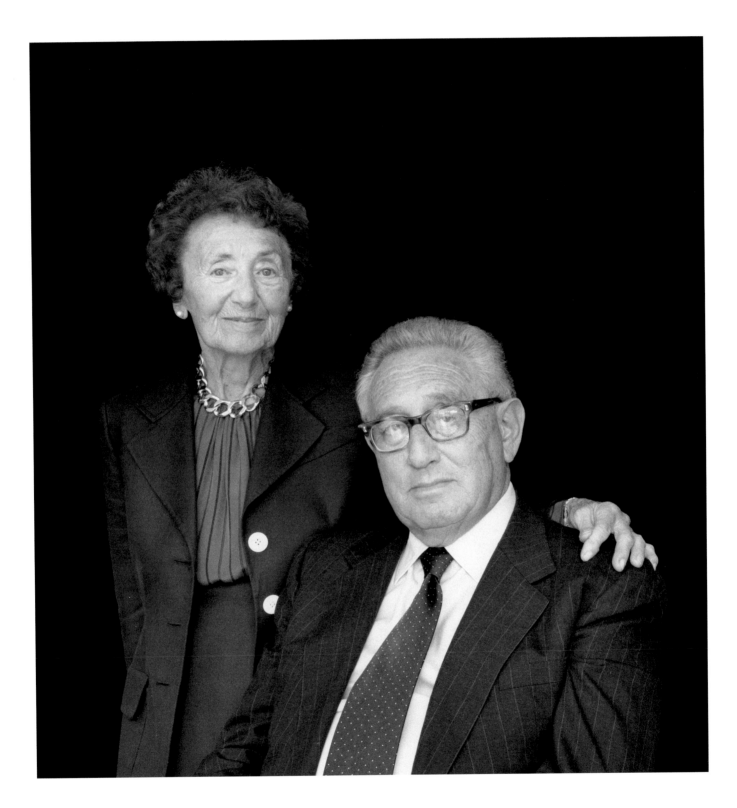

GALLERY DIRECTOR **FRISH BRANDT** [*and*] **AUGUST FISCHER**

San Francisco
1994

FRISH BRANDT Just about anything I have to say about being August's mother is banal compared to the fact of it. Don't be deceived by this picture: he is not merely three; he is an ageless boy. Nor is he always so serious. He is a boy in love with literature. He's certain that it's Mike Mulligan reading the newspaper at our little coffee haunt and when confronted with trombones or butterflies remembers odd lines out of other favorite tomes. He's obsessed with moisture as it goes up into the sky to form rain and has been describing the workings of a steam engine to me for a year now. As I watch the world enter August I see a new order|disorder. Words, his and now mine, map the distances between thoughts, the continents of concepts, only inadequate vessels, but ours.

I didn't know that at two, and well before, one could have convictions and strong opinions. August, however, is a man of many preferences: ravioli, tight pants, backhoes, only certain yogurts, Gordon more than Edward [those with boys will understand], the brown boots with the tab in back, his Florida Marlins hat, and pretending.

At two years and two months August announced to me: "I don't want to go home." It was late Monday afternoon. We had recently returned from a few days in New Mexico, and he was speaking to me from the back seat. Driving, I said, "You don't want to go home? Where would you like to go?"

"New Mexico," he delivered conclusively.

"You know, August, if we move to New Mexico that means no more San Francisco." And quicker than I could turn my head he announced, "No more gallery. No more school."

And at three years August pronounced [upon leaving the open-air market], "I was happy, then I was happy, then I was happy and *suddenly* I was *so* happy!"

Everyone deserves to know someone like August at some time in their life, even if he didn't say, "I love you as much as 13 wildebeests piled on top of each other."

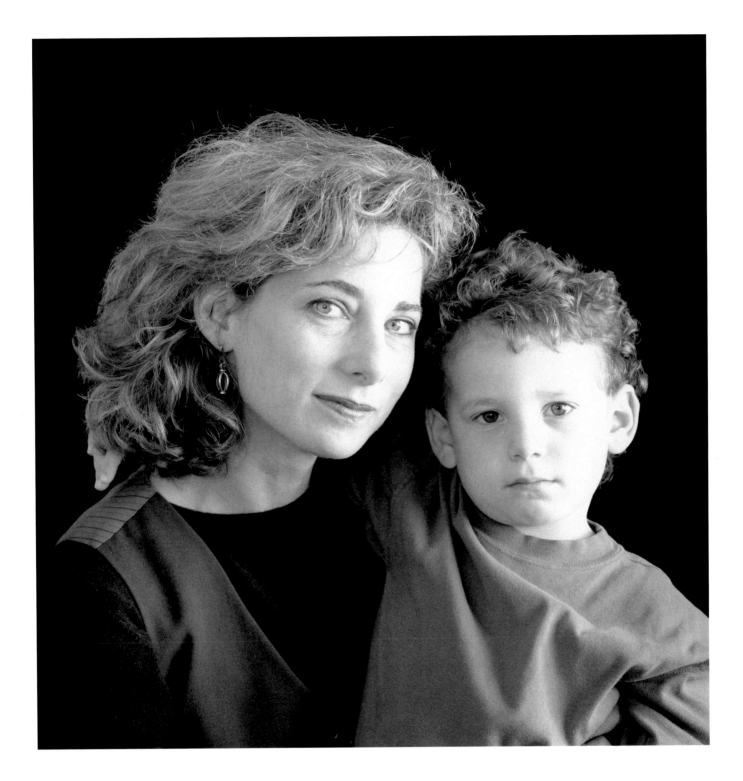

WRITER **KATHLEEN TYNAN** [*and*] **MATTHEW TYNAN** ARTIST

London
1993

KATHLEEN TYNAN When Matthew was nine, his father died. It was typical of this child that, in his own watchful and oblique way, he came to my rescue. He saw me picking up the pieces of daily life while arranging the unfamiliar business of death. One day in my study in Santa Monica, shortly before I set out to bury Ken in England, and exhausted by the demands of the moment, Matthew came up to me where I worked and, for a silent while, fiddled around with a bunch of paper clips lying on the desktop. I paid no attention. When he left, I looked up and saw that he had spelled out, in paper clips, "Life. Love. I love you."

We went to live in New York, where my daughter Roxana, then thirteen, dealt with loss, a new school, and a new life with the intrepid buoyancy she had shown every day of her smiling life. Matthew, on the other hand, was fearful of his new school, and suffered the nightly grip of vivid and terrifying dreams. In elaborate scenarios of his unconscious [which he would recount the next day] he looked the Grim Reaper in the eye, even offering to take the place of his father.

His response to the waking hours would be set down in poems: At age eleven he wrote

I feel it coming. I am dying away

the metaphysical god is not dismayed.

A year or so later morbidity gave way to mere loneliness; loneliness to boredom. Boredom to curiosity. Curiosity to cats and companions, to baseball, sleepovers, and survival in the city. The summer he was twelve, I sent him with his cousin to camp in some corner of New England, a place which blithely offered the Puritan ethic at its bleakest—and by accident [or of necessity] where Matthew learned to be funny. In his willful-elegant refusal to be gung ho he became instead the entertainment, learning to select and arrange the lived narrative for his own ends, which is the writer's prerogative.

He wrote fewer poems; faced another daunting school, in London; and went up to Oxford to read English. Last time I spoke to him, which was a month ago, he was on a beach in Thailand. A temporary dropout? Writing a novel? Looking for love? Certainly shaping the narrative, in his idiosyncratic, original way and in search of the joke.

MATTHEW TYNAN Oh My Mother: The most important things are often better left unsaid. Such is the immutable pact between a mother and her son. My mother taught me this; not in words, but through the tiniest gestures of her affection and in the most delicate expression of her pride in me.

Her writing offers a clue to her character; the elegant and honest prose belies profound and fiery passions. Like the warmest coals that conceal a fire within. We, her friends and loved ones, bask in that glow.

I could continue and fill volumes full of praise and admiration for her, but I dare not ramble too long. My brevity, I suppose, is an expression of fear; a fear that I might disturb that deep well of unspoken love with too many loose, imperfect words. For this reason I will retreat once more into the warmth of silence.

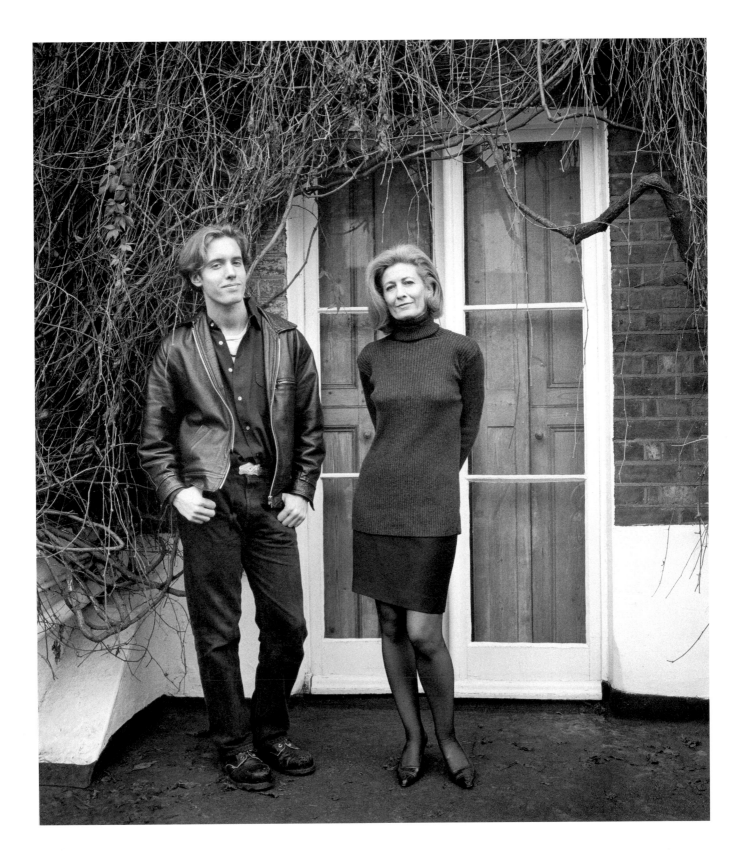

FILM PRODUCER **DENISE TUAL** [*and*] **JACQUES AND CHRISTIAN TUAL** UNIVERSITY PROFESSORS

Paris
1993

JACQUES TUAL About my mother, what can I say? It's been a rich but difficult relationship from the start. She was energetic, bright, ambitious, and terribly busy, a French woman film producer in the days before the Second World War and right into the seventies. A rare enough thing for any French woman to be then, or even now.

She married thrice, once to escape from a rather loveless, turn-of-the-century Parisian-bourgeois atmosphere; the last two times because she was passionately in love with brilliant, handsome, poetic, self-destructive men.

My brother and I admired this mother-in-a-hurry we never quite saw enough of. Indeed, she seemed to be more in love with the film world than with family comforts. We were raised in rather a grand way with servants and large houses, all of which vanished after a number of reversals of fortune. But she had the intelligence to send us to school in England, then to Italy, a cross-cultural experience which mitigated all the other insecurities confronting us.

She did insist on not treating us as children from the start and we were expected to deal on an adult footing with both famous and unknown grown-ups. That, along with learning English and Italian, kept us pretty occupied throughout. It also directed us towards an academic rather than a showbiz career, for security's sake no doubt.

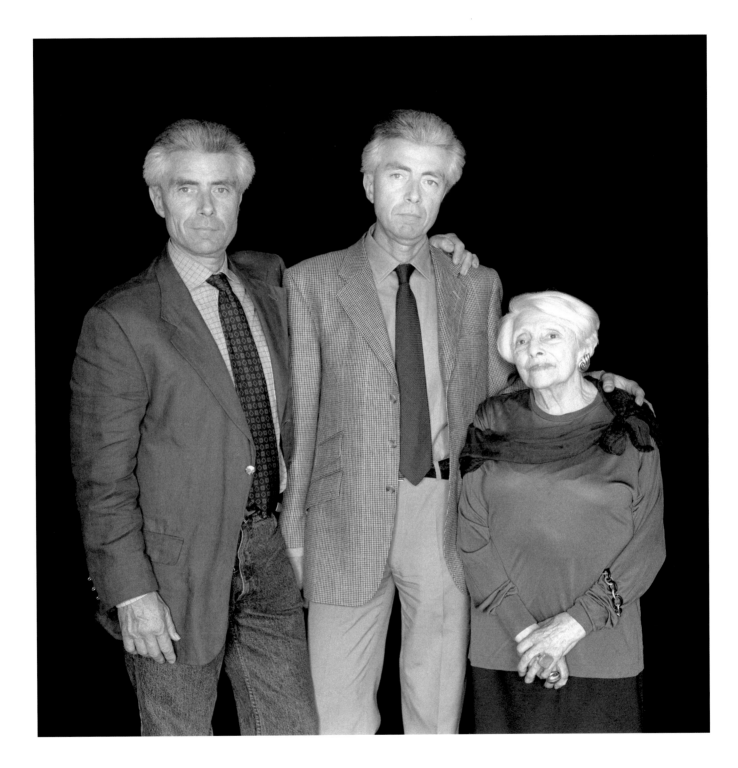

RESTAURANT OWNER CARMELITA TRUJILLO [and] DOMINIC TRUJILLO RESTAURANT WORKER

El Rito, New Mexico

1994

CARMELITA TRUJILLO Dominic is everything a mother could want, if only he'd continue his education. He's always been special, since before he was born. We waited a long time to have a baby. And when we found out we were expecting, it was very special. By age nine months old, Dominic was infatuated with the moon. He could say it in Spanish and English. As soon as he saw the moon at night, he'd go crazy. He's very intelligent and it showed at a young age.

He's very considerate. He protects his four younger sisters. One time when he was two years old, his one-year-old sister sat on a pile of red ants. She was very stubborn and wouldn't get off the pile...he kept trying to pull her off even though he was being badly bitten. Even now, he does everything he can to help them out. He checks on his grandmother all the time and helps her get wood. He's always thinking of others. It's one of the reasons he's not back at school—he's trying to help us out.

DOMINIC TRUJILLO I've never been close to anybody. I've always been kind of a loner. Mom is a good person. She has a good heart. I haven't spent a lot of time with her. I was in school and sports and my parents were always at work so I didn't see much of them. I have a lot of the same physical features as my mom and some of her attitudes, like her mean streak. It takes more to get it out of me than her, but it's in there. I can be a good person like her, too. Sometimes I can get that to be brought out. I stay because they need me here.

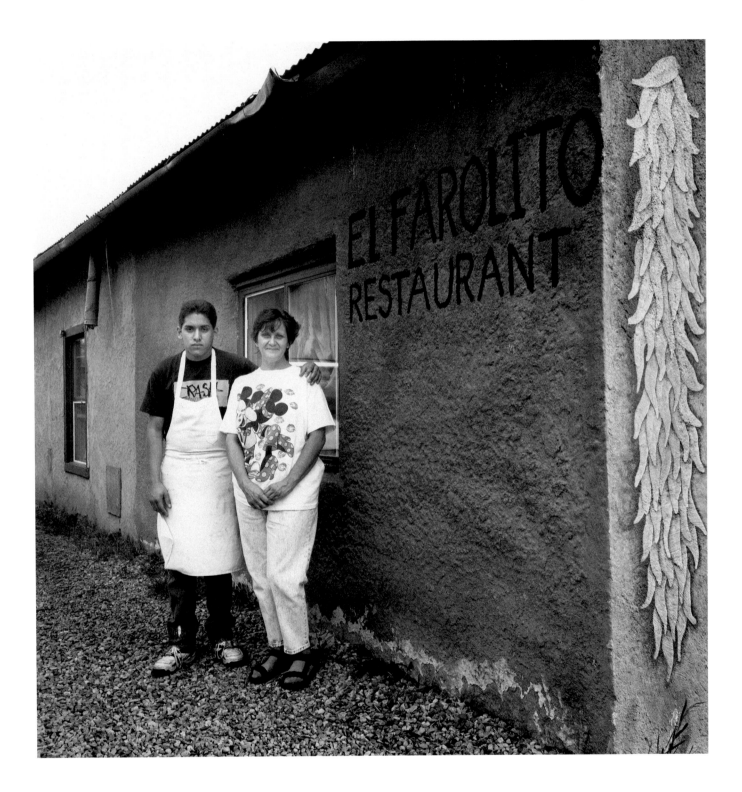

CONCERT PIANIST **RILDIA BEE O'BRYAN CLIBURN** [*and*] **VAN CLIBURN** CONCERT PIANIST

Fort Worth, Texas
1994

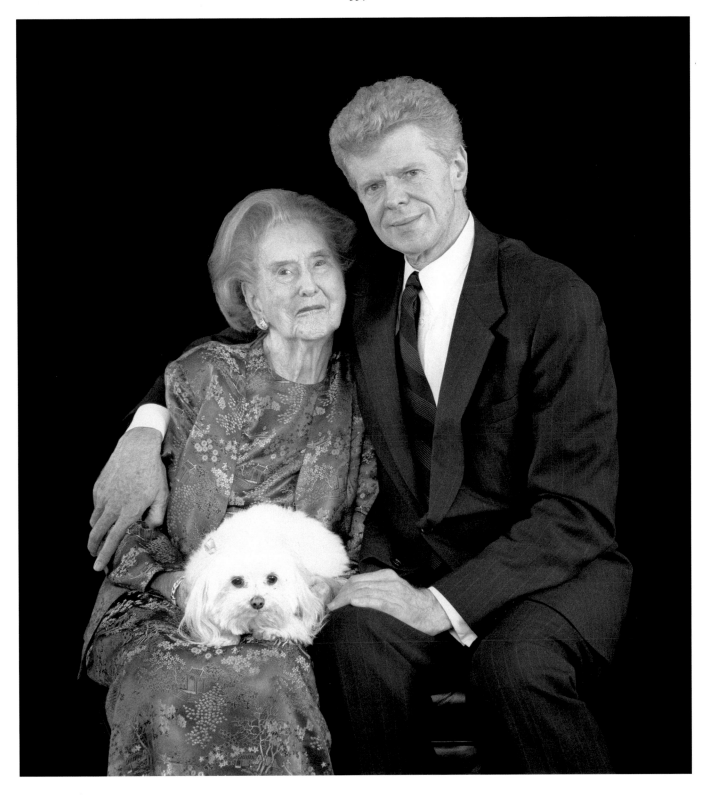

POLITICAL ACTIVIST AND POET **ROSE STYRON** [*and*] **TOM STYRON** CLINICAL PSYCHOLOGIST
New York
1995

FISHING [WRITTEN IN 1964]

Tom-Tom is sitting on a half-wet rock
his fishing pole held tight;
the sun makes hay of his new-mown hair
while he's waiting for a bite.

What is he thinking of all the while
he sits at Roxbury Falls?
He doesn't stir when a frog hops by
or the noisy bobwhite calls.

Perhaps he's thinking of the cedar trees
he'll climb when he is seven,
or the big box kite he'll make, and then
the ride he'll hitch toward heaven.

I'll bet he's concentrating now
on a crawling beetle-bug
he'll sneak into Susanna's bed
when she's all warm and snug!

Or is that bending head a-trance
with glories of the deep?
When next I look Tom-Tom will be
just Little Boy Asleep.

From *Summer to Summer*
by Rose Burgunder, published by The Viking Press, © 1965 Rose Styron

ROSE STYRON That was Tom at four. At nine, when his Dad was away, he might be found asleep at the bottom of our midnight stairs, tennis racquet in hand, ready to protect his Mom and sisters from every country monster. Such intensity of purpose and imagination, plus an extraordinary compassion for man and beast, led him to spend his twenties devising innovative care for the homeless, the abandoned, the children of the poor, and to his calling in the discipline of clinical psychology. In between [when he was not 100% devoted to excellence in poker or yoga, snake-raising or hang-gliding or girls] we've had a mother-son relationship that has brought me only joy. Sharing tennis courts and fishing boats, Scrabble boards and treasure hunts, books and art and wildlife, far cities and islands and mountain trails and ocean reefs, and problems close to home with Tom, nothing tickles me more, still, than correctly calculating how long it will take his serious face to break into a mischievous lasting smile.

TOM STYRON As a child, I kept a secret from my friends for fear of hurting their feelings: It was the knowledge that my mother was perfect in every way and theirs were, by comparison, not nearly so great. I absolutely delighted in my mother's warmth, kindness, and reliability, her amazing beauty and intelligence, her playfulness, compassion, and devotion to me. I loved her very much.

As an adult, I realized that some of my assumptions about my mother were based in fantasy. Others were not. These included her enduring warmth, kindness, and reliability, her amazing beauty and intelligence, her playfulness, compassion, and her devotion to her family. I love her very much.

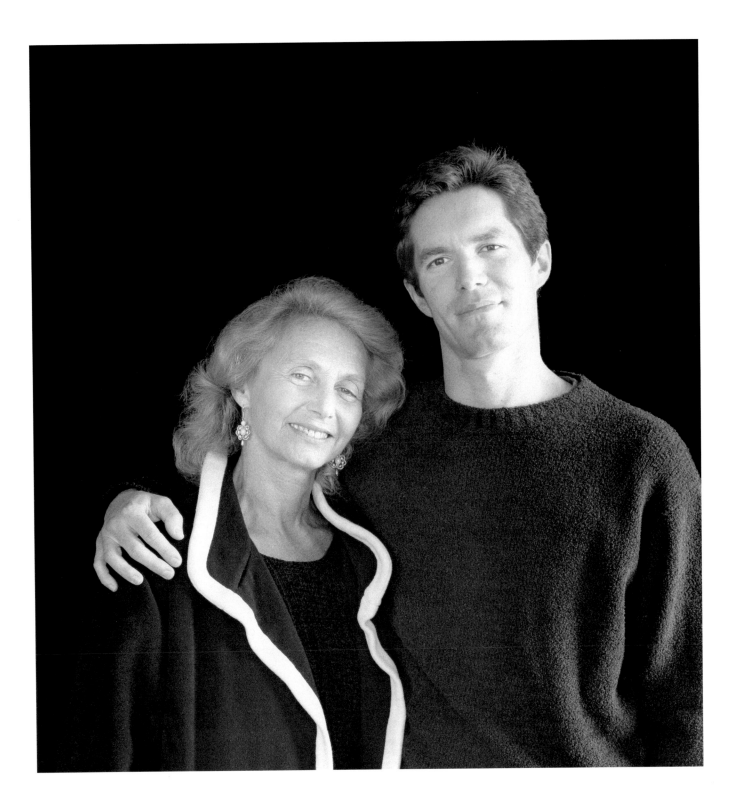

WRITER **DOROTHEA STRAUS** [*and*] **ROGER W. STRAUS III** BOOK PACKAGER

New York

1994

DOROTHEA STRAUS The paucity of language is shown by the use of a single word, "mother," to cover numerous relationships created by the passage of the years. Is it possible that person [barely recovered from childhood] is myself, the new parent of a tiny, helpless infant son? The schoolboy and camper with no time for more than a nod in my direction; the young man who left home, so casually, never to return; the father, who, generously, made me the grandmother of three—are they one person? Am I? With thankfulness, I am still linked, today, to an able, handsome, middle-aged giant, but those former selves have disappeared forever. Only the titles remain unchanged.

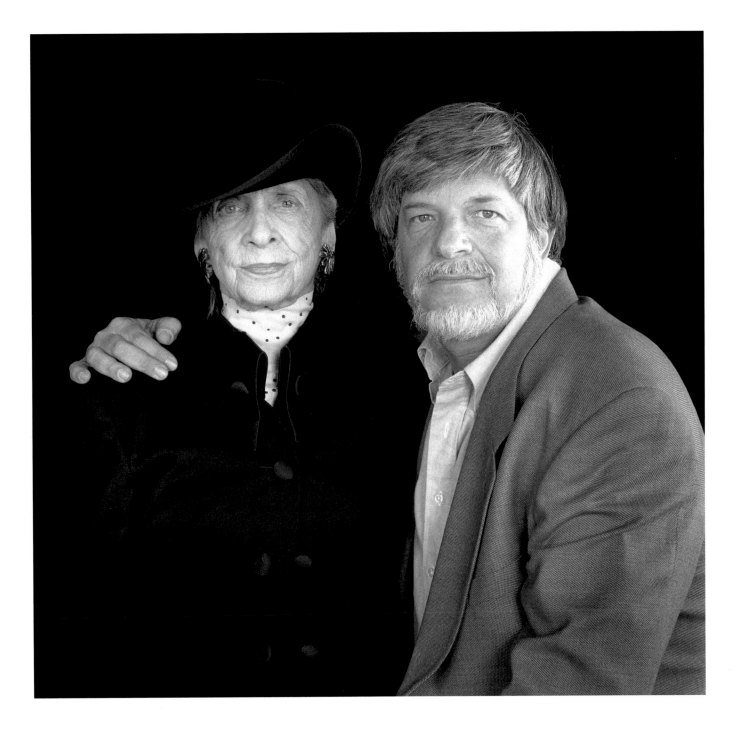

CELEBRITY PHOTOGRAPHER **EDITTA SHERMAN** [*and*] **BRADLEY** HOUSEHUSBAND **AND LLOYD SHERMAN** SCIENCE EDUCATOR

New York
1993

LLOYD SHERMAN To say that my mother is a different sort of mother would undoubtedly be an understatement. Quite simply, my mother is a free spirit, only slightly tempered by her Roman Catholic|Italian upbringing. What mother does comes out of a generous heart and an unbridled Fellini-like imagination—whether it was her managing her fifty-acre farm in Maryland, or decorating her homes and herself in period pieces from antique stores and thrift shops; acting in films; managing studios; toe-dancing the Dying Swan for all comers; modeling; being a television talk show guest; a lay stockbroker; being "The Duchess of Carnegie Hall"; or, perched behind her gargantuan eight-by-ten camera, photographing "Men of Achievement." In a sense, Mother has done it all [except of course becoming the ever-elusive millionairess]. The notion of "mother" does not emerge easily through her many projects and personas. Yet, through it all, I well remember her persistent mothering concern that we [her five children] be well nourished, well clothed, and well educated. She cared immensely that we should be trained in the performing arts, and should find the same pleasure in them that she did. I remember one occasion, at a playground, when Mother wanted to join the children [some of whom were my acquaintances] on the swings. I can still see her now, driving her swing higher than any of those children who were also swinging as hard as they could. I buried my head in my father's lap, embarrassed over Mother acting so silly. My father said to me that I should be proud to have a mother who was so happy and full of fun.

BRADLEY SHERMAN The Studio is the center of my mother's universe. It is located on the top floor of the building that houses Carnegie Hall. She first took residence there forty-five years ago. To us, the Studio lies more nearly between Heaven, the Garden of Eden, and Hell. The vaulted skylight which runs the length of the chamber guarantees communion with the gods. The wall of windows which affords a vista of Central Park surrounded by its stand of buildings keeps the primal past ever-present. And the roof of the concert hall and the studios below—crucibles of art—spark the impulse of creation in the anguished soul. Stories give a portrait of its denizen that few could know.

My mother once sat in a restaurant for a month and never ate a thing. She was lying in wait for a man who frequented the place; he had borrowed a cane she had and never returned it. It wasn't worth anything—just a mother-of-pearl handle with gold filigree—but she loved it, and she used it to set off a black cape that was her insignia. She cried about it to everybody, and they heard the story from beginning to end. "The rascal," she would laugh, "He stole it!" Years later, the man was spotted on the street, accosted and threatened by someone who recognized the mother-of-pearl handle. The next night my mother's bell rang, and when she opened the door, there was the cane lying on

the mat. A week later it was in the pawnshop; the upside-down image she was bringing into focus on the glass of her camera was that of Marcel Marceau, and the film in the camera was purchased with the money she got for the cane.

There is a double-sided desk in the Studio, a copy of a Louis XIV. It's falling apart, but it's where my mother has always conducted business, eaten, and served tea. It is where we ate when we came to live here after high school, which each of us did for a year or so, as we left the "bide-away home." That was what my father called it—a bide-away home—it being in his mind a place where we children were to be cared for until he, in his role as manager, could turn the photography business around. A fortnight, six months, maybe a year: that was all the charity he imagined was needed. We were there six months…a year…two years, and throughout the duration, my father's health continued to decline. When he died, and the business lost all promise of supporting us, Bethlehem, as the home was named, became our refuge.

I was too young to remember the days on the farm which was the last place that we had a home as a family. So my most vivid memories of mothering were here at the Studio. I was eager to get my life rolling at the time and was thinking of joining the army. When I informed my mother, she rose out of her chair and made an inquiry of me concerning my sanity, "Are you dreaming?" I was stunned by her alarm, and straightaway imagined there must be some part of the army I had no idea about. Embarrassed, I turned without question to pondering other venues of maturation.

Ultimately I went away to college and while I was gone my mother took to responding to my draft notices from the Selective Service Board by quietly placing them in the trash basket. When the Board called the Studio at the end of my second year, she informed them that I had gone off to Europe and hadn't been heard from since. Several months later, she placed a ticket in my hand. When I got off the plane, I was in Copenhagen.

After I returned, I up and got married and when my mother learned of it, across her desk, a tornado touched down inside her. All I could do was grit my teeth and watch the devastation. It took a while before the king's horses and men could get her back together.

Above the desk and on the other wall are the portraits. These are of the many celebrities she has photographed; her life's work, her art. They are her true sons: they're born of her sorcery. Some of them are badly faded, but, like her, they never grow old, just more desperate for illusion. In a very real way, she gave herself to them for us, and they hang here now as trophies of lost children. In each portrait there's a story of a life, and in each, stories of a loss that made the portrait possible. Together they are a river of memories coursing through her, ever restless and yearning.

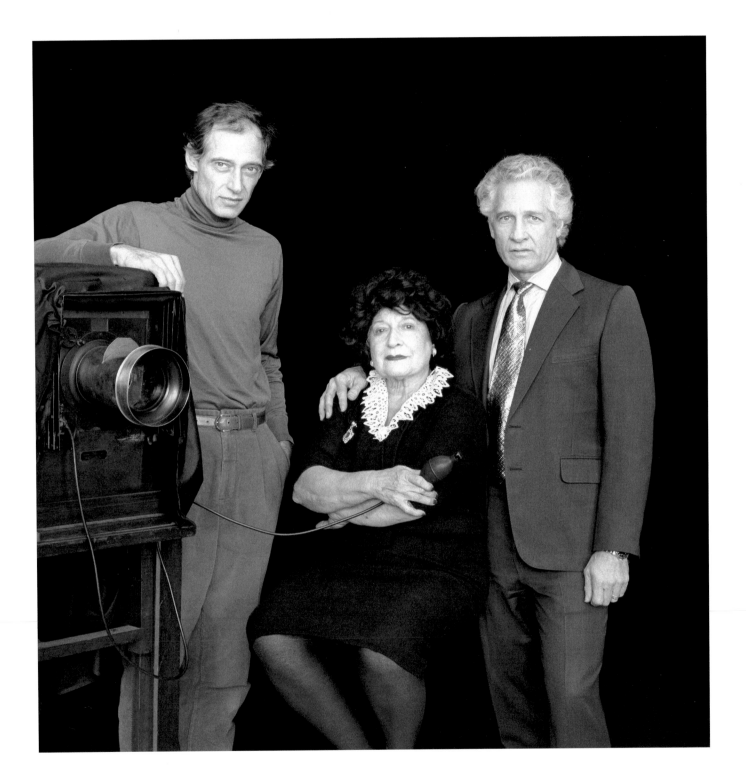

WEAVER **MAE ZAH** [*and*] **PETERSON ZAH** PRESIDENT OF THE
NAVAJO NATION
Window Rock, Arizona
1994

MAE ZAH In the days when my son, Peterson, was growing up, we lived together in family units. We lived with my side of the family, Peterson's maternal grandparents. He was an only son among several sisters, so much responsibility was placed on him. He did the chores of an adult at a young age, such as bringing the water, chopping wood, looking after our immediate household, and caring for his grandmother and grandfather.

He was perceived as being very different even as a young child. He did not throw tantrums. Then, as now, he had the temperament of his grandfather, who had no anger in him.

Peterson did not start school until he was nine years old. When he did go, it was against our wishes. My sister was enrolling her children at the Tuba City Boarding School. She invited Peterson to go with them. The Keams Canyon Boarding School was closer and the children could be taken by horseback, but it was full.

His father and I wanted him to stay with us and train to be a medicine man. And besides, he had no nice clothes; what he had was old and torn. But he wanted to go to school so badly that it did not matter to him how he looked. Soon he became fretful and would not eat. That's when his father and I decided to let him go.

His father told him that since he did not choose to stay home and live our kind of life, that there was no turning back. Peterson promised that he would return and help the family again. He left for school in Tuba City. My son had never been separated from me and it was very hard. I worried about him and many times I wept.

When school let out for the summer, Peterson returned home. The older he grew, the more involved he became in maintaining our households. One of his favorite chores was to prepare the sweat house for his grandfather. He liked it because he could hear the songs and stories of our people. He loved to listen to the older men who attended the sweat bath ceremonies.

Though it was hard to be apart from my son, today I feel it was worth it. He was raised in our traditional ways and has a strong foundation in our Navajo cultural and religious values. He had prayers done for him and for his education. He values and respects his elders. He has lived among the white man so he knows that life. He has returned to lead his people.

PETERSON ZAH My mother is a pure Navajo. She lives according to the Navajo traditions. She does not speak one word of English. She taught us Navajo values and how to remain true to our traditions. She was probably the stronger of my two parents. She taught us to go out and learn the white man's ways and experience living in the non-Indian world. But she said we should never forget where we came from and where we have been. She told me to respect other cultures and urged me to experience them for a short time.

My mother was one of the better-known Navajo weavers. She always spun wool into the night. As she was spinning wool, she would talk to us until we went to sleep. She told us that there are a lot of people with different songs, traditions, and languages but we are all children of Mother Earth, of some higher entity, and we should always respect and appreciate life. She always said, "You should be honest. Not for anyone else, but for yourself. And do not ever think that when it gets dark you are free to do anything. The night is your grandfather. Although you cannot see and people do not hear you, by the fact that your grandfather is there, you know he would be greatly disappointed if you were dishonest. You should always follow your own traditional values day or night and live by those principles."

My mother always owned a herd of sheep. She would talk to the animals and they would understand. The sheep meant everything to her and the herd provided our food and livelihood. She wove the wool that came from them. If you look at her life it revolves around the sheep and lambs. She mastered that lifestyle. The sheep belonged to her and responded to her.

One day, we decided that our mother had been working too hard all her life. We wanted her to take a vacation from herding sheep and weaving rugs. My mother agreed to do this and we thought she would finally get some rest. My sisters and I took her sheep and divided them amongst ourselves. A few months later, our mother got sick. Week after week, we took her to the hospital but she did not get well. One day I was alone with her and she said she missed the presence and sound of her sheep. She said she did not like being idle. It dawned on me that she needed the sheep because she had depended on them all her life. That evening I drove all night to put the sheep back into her corral. At about four in the morning, my mother woke to the sound of her sheep. She ran out to greet them with tears coming down her face, and she was cured. From that day on, she never got sick again. She still lives out there, caring for her sheep.

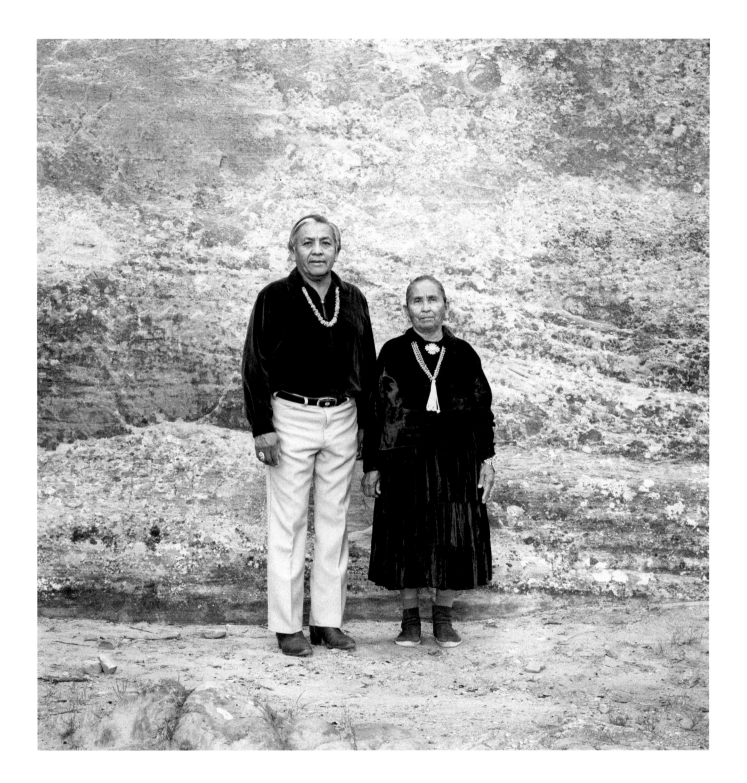

RETIRED BOOKKEEPER **FLORENCE WINICK** [*and*] **EUGENE WINICK** LITERARY AGENT

New York
1994

FLORENCE WINICK Eugene is an independent, self-made man. Even when he was a little boy, he knew how to take care of himself. When he was eighteen months old, he was found walking the stairs alone. When confronted, he said, "Don't wolly, don't wolly."

Eugene was born to parents who had fifteen siblings between them. He was one of the first cousins born, but they were multiplying and soon there were thirty-four. Some of the best times were spent at the family get-togethers on both sides. Each side had a "family circle" meeting once a month. So he grew up in a big family that was very close. Even now, family is the most important thing to him. Family members still call him for help, and he goes out of his way to do anything he can for them.

When Eugene entered college, his greatest dream was to possess his own automobile. This he was promised when he graduated college. But he wanted it now, so he worked odd jobs and earned enough to purchase an old Hudson for sixty dollars. Not seeing him study while in high school, his father told him that all he would be good for would be a ditch digger. One day, he wrote me, telling me [and not to tell Dad] that he was digging ditches for a construction company! Over the weekends, he served beer in the college's social hall. He did everything and anything to be able to have the car he wanted. On his next vacation, he made the trip home to New York and returned to Colorado where he sold the car at a profit. This was his first business venture.

EUGENE WINICK My earliest recollections include the wondrous results my mother produced with plain old pots and oven pans. The prodigious quantity of food she provided was a holdover from nourishing her own family of eleven in Jersey City—seven boys and four girls—when, as she recalls, someone was always bringing a friend over for lunch or dinner. This aptitude to nourish extended over our entire relationship. Happily for me, her fortifying resources also fostered a spirit of independence at an early age.

When I went off to college she knit me a turtleneck sweater. I wore it regularly. It is so durable that it was worn by my youngest daughter when she went off to college thirty-eight years later, and remains in her use. That sweater neatly symbolizes mother's strong fiber which was woven into a flexible and forever accepting, loving and nurturing presence. When she realized that I was in need of a replacement sweater, she set to work on it at age eighty-three.

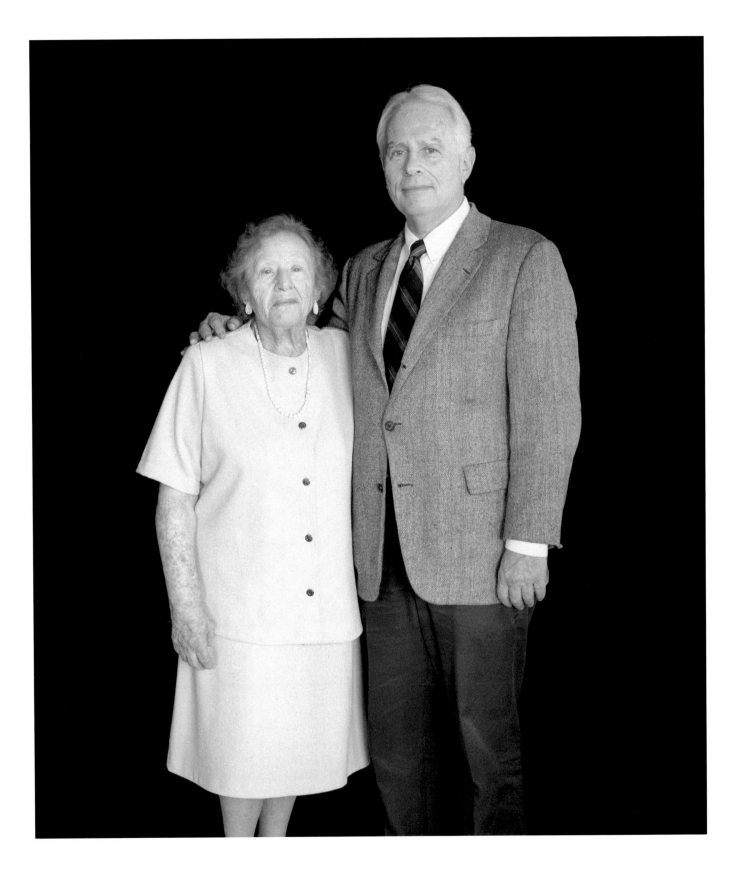

FEMINIST AND **DOROTHEA WILKINSON** [and] **JOHN SANTOS** MUSICIAN AND COMPOSER
COMMUNITY ORGANIZER
San Francisco **AND FRANCO BARONE** CLOTHING DESIGNER
1994

DOROTHEA WILKINSON My first reaction to this photo-graph was amazement at those eyes. They are Papa's [my grandfather who passed away on Christmas day, 1936]. It's amazing how his spirit has been part of all of us since then. Papa used to say: "Think with your heart; feel with your mind." It's the way Franco and John live. When Franco was born, my mother took me aside and warned me that the gypsies would try to give him *mal de ojo* [evil eye] because they would be afraid of his spirit through those eyes. At times it was really pretty funny as my mom followed my friends around the house suspiciously, pouncing if there was a move towards the baby.

As time—and three more children—came by, we all remained under Franco's spell. Being oldest, he was the boss, and used those eyes to demand, command, intimidate, and control all the other kids, but always with a mischievous, comedic tone. He has a wonderful sense of humor which is the nucleus of his being.

When John was born, all our lives were suddenly uplifted. Grown-ups and children were bewildered by this totally helpless, yet commanding, spell binding child. As they grew, the clashes between Franco and John were pretty awesome; the subject of many hilarious stories our family enjoyed through the years. In retrospect, we have not had dull lives.

Franco and John developed a bond that was so natural. They would look at one another, and we could see the telepathy working: gestures, expressions, subtle move-ments. They worked, played, ate, and joked happily, determinedly, as though the whole world and everyone in it was their "place," which in truth it is. They are both loving and compassionate [Papa's word] yet very strong and able to make choices honestly, decisively, and without hurting anyone. Whenever someone mentions Franco or John, I immediately puff up with pride, because they always want to tell me something special, either deeply emotional or very funny. Recently I was in church with my jazz choir and I felt something drawing me. I picked up a book which turned out to be excerpts from the Bible. It opened to something about "The tree is judged by the fruit it bears." I knew then it would be okay to be proud of the fruit of my life, even as I am proud of my ancestors and feel their spiritual presence in our lives.

JOHN SANTOS My mom has always amazed me. She *always* worked, often two jobs, while raising four of us, and we weren't easy. All four of us have always been ravenous eaters. Just feeding us was a full-time job. We used to fight a lot, too. Although my dad's presence was very strong, somehow the household felt matriarchal. Her rule was usually subtle and loving but she certainly wasn't beyond the semi-regular tirade. Once we were big enough that she couldn't catch us anymore, she'd hurl a high-heel shoe or whatever was handy. Luckily, her aim wasn't so great.

Even during these acts of apparent aggression, she couldn't conceal her warmth and love. If we said the right thing while she was giving chase and hurling items with what seemed to be intent to kill, a smile would force its way upon her face, rendering her helpless to inflict any serious damage. "I love you Mom" or "Don't try out for the Giants," would sometimes do the trick.

I attribute most of her flexible, yet unbreakable character to survival techniques learned in San Francisco during the Depression and post-Depression years of the thirties and forties as the oldest child of a large Puerto Rican|Hawaiian|Irish family with a turbulent history of migration and survival. She's always been there for us to deal with any problem, no matter how large or small. I can think of no other role model who exemplifies the type of person I strive to be. She's wise, courageous, full of love, and as any of her four husbands would attest, *she's a warrior.* I love you Mom!

FRANCO BARONE When we were children, because of our age difference, I often baby-sat my younger siblings. One evening, when my mother returned home, John complained to her that I wouldn't let him do something [I don't remember what] that he wanted to do. My explanation [discipline! discipline!!] was supported by Mom in front of John—but she later pulled me aside and said: "In the future, say *yes* whenever you can." It's the rule she has lived by. It was a great lesson about the adventures that my life would bring.

In adulthood, John became my guardian angel. At a time when I feared devils and beasts were sucking me into eternal darkness, John reached in and pulled me out.

In 1988 I was diagnosed with cryptoccal meningitis [HIV-related] after a harrowing seizure in a hospital room. I remember a terrifying night with my body convulsing from a lying position to a seated position, then back down and up and down continuously [I am reminded of the *Bride of Frankenstein*], eyes flashing open to reveal strangers [nurses, actually] trying to subdue me, holding my arms and legs in place. The room was unfamiliar and dark, and the large picture windows beckoned with darkness. I feared these people restraining me. I feared the darkness, the unfamiliar frightening voices [preparing me for my journey to the underworld, I thought]. As I fought these devils, I tried calling for help but could only speak gibberish; as I tried to resist the convulsions my body was putting me through, I could hear in the distance a faint voice, somewhat familiar, calling my name softly. I opened my eyes to see John standing at the foot of my hospital bed at three o'clock in the morning. He was an angel with wings. All my fears melted away in seconds. He held my hand and said he would take care of me, not to fear. The beasts around my bed turned to sweet, concerned nurses in green and white, and I was bathed in warmth. My brother spent the night in the bed next to mine and I knew I was safe.

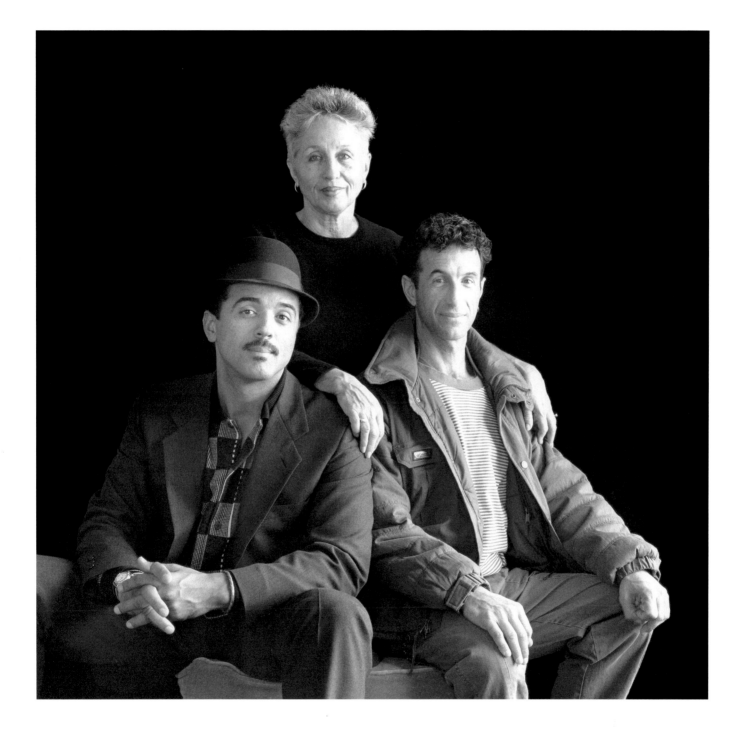

RETIRED SCHOOLTEACHER **MILDRED WEST** [*and*] **ARCHIE WEST** RANCHER

Santa Fe
1994

MILDRED WEST I always warned my four boys to watch out for rattlesnakes. One day they brought one to me in a jar. How they ever did it I don't know. But we took it with us up to Puye when we moved there for a few years. Then the war broke out and everything changed. My husband was a painter and was working in the WPA. Those were lean days.

We started out with 240 acres, but lots of it's gotten sold. It's kind of wild, beautiful country. All four boys help here at the place; we had black-eyed peas last night and we still have common interests. I have a wood stove in the kitchen and living room and the boys always see that I have enough wood.

My life has gone so fast when I think of it. It's a good thing I taught for seventeen years on a Navajo reservation, otherwise I'd be totally dependent on my sons. I taught second grade in public school at Shiprock—the boys were in high school 230 miles away. They were living on their own.

Now, Phil is in the ministry; has a church below Albuquerque. Jerry is painting and has a construction company. John is the oldest; has had lettuce all winter out of his greenhouse. It's down in the southern part of the state.

Archie's kind of quiet. I don't know much about what he does. He loves music. He's a reader, does things, has a homey place. Archie's liked by everybody. He has no enemies. Archie's been at the home place almost always, except two years in the army. He hated the army, wouldn't bring his uniform in the house—kept his army clothes in the well house. He's stayed on the ranch and keeps it all neat and nice.

They're all different, but they've all done something. They haven't been in any trouble. It wasn't my influence. I don't know how much I've influenced them.

ARCHIE WEST My mother will be ninety-three this June and I am fifty-seven. She and, of course, my siblings are the longest of my relationships. And though I cannot know how much or what I've learned from my mother, sisters, or brothers, I'm sure that much of what I've always seen or felt has that edge of gold around it; like the change of the seasons, song of a meadowlark in spring, a line of poetry, horses running and playing after a summer rain or sunset. I have my mother to thank. My lasting image of my mother is of a beautiful woman, a constant figure all my life, strong and steady, sure and unwavering in her own values by allowing me to have my own.

Mother never physically punished her children, though she was certainly able to convey the feelings of approval or disapproval, rights and wrongs by the way she spoke. I guess values can be taught by the way one speaks; reverence for beauty and tolerance, kindness and even love pass on just by the way we speak. I give thanks for being delivered into the arms of a kind and loving mother and I am particularly grateful for having one that allowed me so much freedom. Freedom to run barefooted, dream my own dreams and most of all the freedom to be myself.

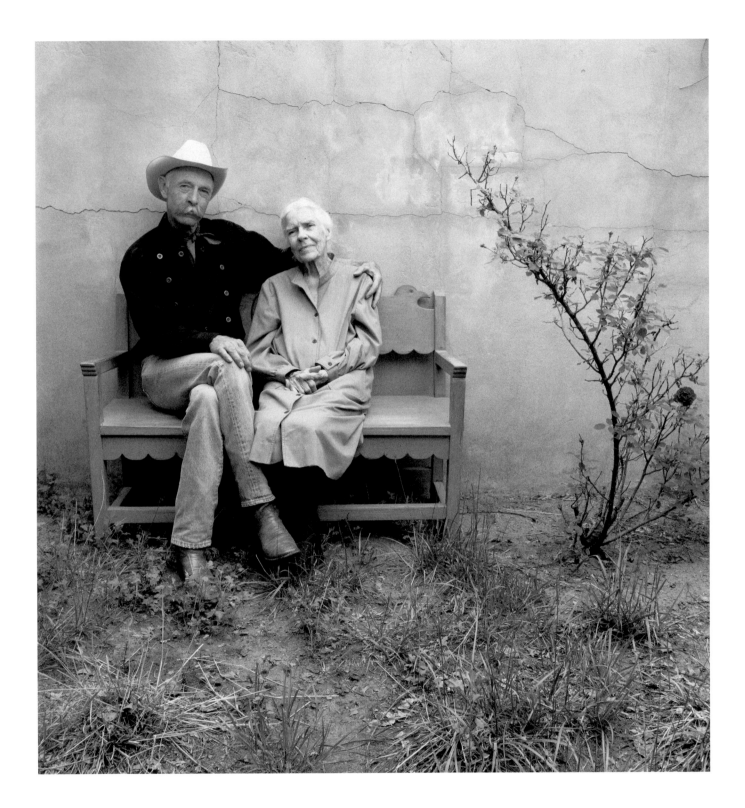

TEXTILE DESIGNER **MARY STRUDWICK** [*and*] **MICHAEL SHANNON** EDUCATIONAL CONSULTANT

New York
1993

MARY STRUDWICK From the time Michael was very small, he was the one who cheered me and comforted me when things went wrong. I was always helped by his presence and rare sense of humor, of what was ridiculous or could be made so. His creativity showed itself even in small ways—in little notes he would write and illustrate with wildly funny caricatures. His arrangement of his possessions in his rooms when he got older was always orderly—inspired like the things he made with his hands for decorative gifts. These qualities have continued through life. For me there is also an understanding between us—a similarity of tastes and ideas that is comforting in my later years.

MICHAEL SHANNON My parents were divorced when I was three years old. Not long thereafter my father went to war for four years and remarried upon his return. This is to say that my older sister and I were raised in a single-parent family, a situation approaching the norm today, but not so common then.

My mother made mistakes in raising her two children, I believe, as I have made mistakes in raising two of her grandchildren. But this is the point I want to make: She has never let me down. At no time that I have been in need of any sort has she ever turned away. She has been a steadfast friend and ally, a model for the wholly "present" person that I have been, and intend to remain, for my children.

Complementing this noble constancy have been a number of other admirable, if less formidable, qualities. She has fostered in me a sense of the spiritual in all aspects of living, my deep involvement with the arts, my enthusiasm for travel, for different people and for unusual things to eat, and perhaps most important of all, for laughter. We are having a good time together.

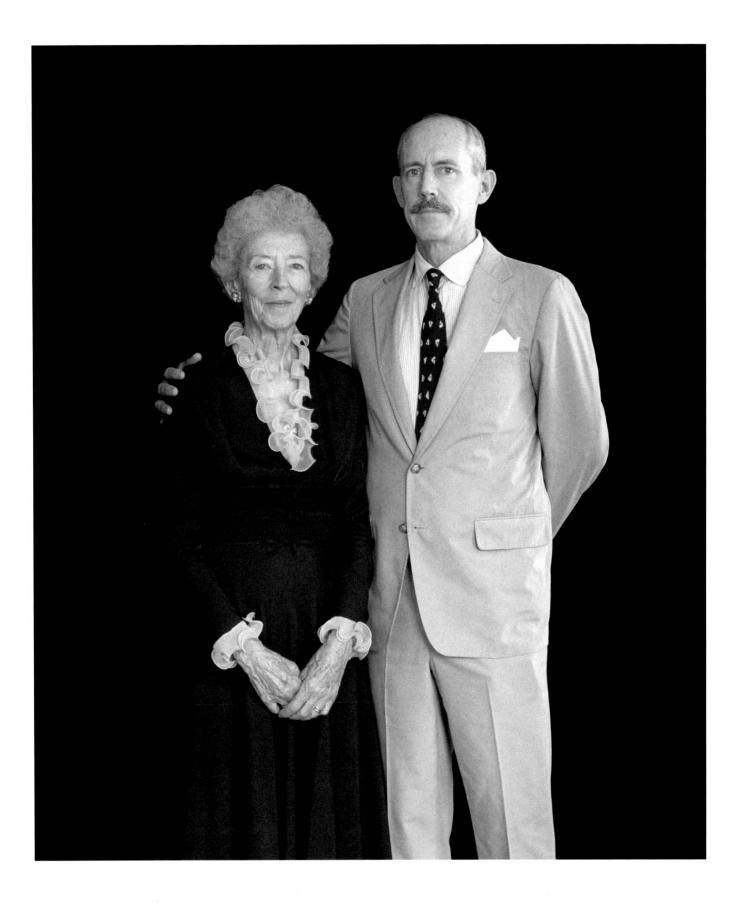

RETIRED NURSE **VIRGINIA CLINTON KELLEY** [*and*] **BILL CLINTON** PRESIDENT OF THE
UNITED STATES OF AMERICA

Washington
1993

BILL CLINTON I never met my father. He was killed in a car wreck on
a rainy road three months before I was born, driving home from
Chicago to Arkansas to see my mother. After that, my mother had
to support us. So we lived with my grandparents while she went
back to Louisiana to study nursing.

I can still see her clearly through the eyes of a three year old;
kneeling at the railroad station and weeping as she put me
back on the train to Arkansas with my grandmother. She endured
her pain because she knew her sacrifice was the only way she
could support me and give me a better life.

My mother taught me. She taught me about family and hard work
and sacrifice. She held steady through tragedy after tragedy.
And she held our family, my brother and me, together through tough
times. As a child, I watched her go off to work each day at a
time when it wasn't always easy to be a working mother.

As an adult, I've watched her fight off breast cancer. And again
she has taught me a lesson in courage. And always, always she
taught me to fight.*

*EXCERPTED FROM THE 16 JULY 1992 SPEECH | TO THE DEMOCRATIC NATIONAL CONVENTION, NEW YORK

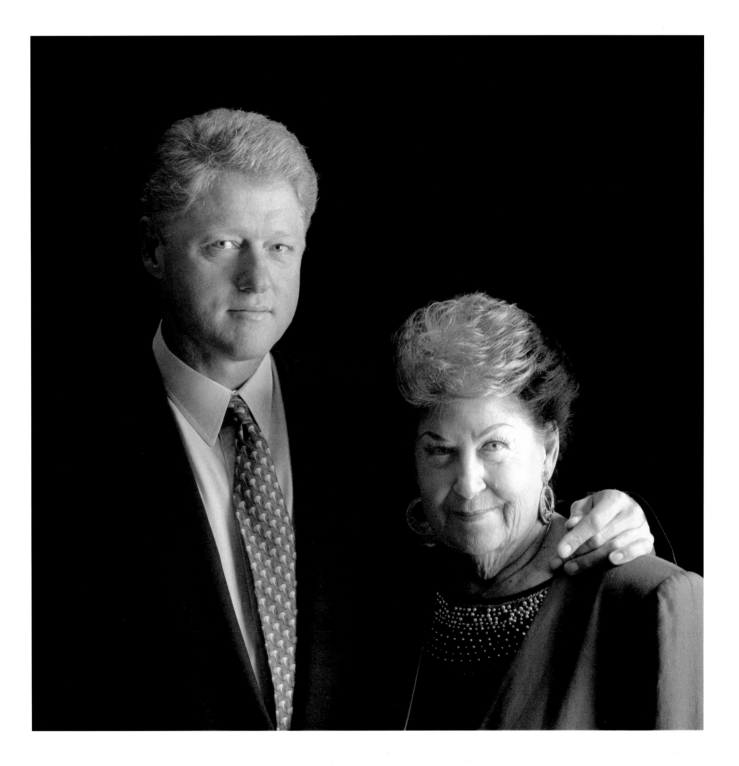

RETIRED REAL ESTATE BROKER **BELLA PASTERNAK** [*and*] **STEVEN, ALVIN, AND JERALD PASTERNAK** ATTORNEYS

Riverdale, New York
1994

BELLA PASTERNAK You can say I'm stubborn, determined, very determined. I always was. When I make up my mind, it's nearly impossible for someone to change it. Honesty is the most important thing to me. People might not agree with me all the time. I'm outspoken and opinionated.

I was born in Rumania on 7 November 1928, a seven-month premature baby, number seven to my father...and I survived. I went to Rumanian schools for four years and finished seven grade levels. Then there was no more offered in our area. I won a scholarship award in seventh grade that would allow me to go out of town to get further education. But, unfortunately, in September 1940, when I was to go to school, Rumania was occupied by Hungary. I had to go back to school and start over...learning a new language. Soon education was forbidden to Jews. Radio was forbidden, newspapers forbidden to us... but I survived.

In 1944, I was fifteen years old and I was street-smart. Everything was rationed to us: milk, sugar, salt, everything. I got involved in the black market. I bought and sold everything—eggs, sugar, flour. I was a merchant and I befriended a police captain in the main city, three miles away. He knew I was doing illegal things. I bought him off.

A week before a big roundup of Jews was to occur, the captain gave me a warning to get out. My family didn't believe me. They couldn't believe we would be taken from our home. The morning of the roundup I refused to do the house chores. No one believed me until they knocked on the door and said, "You have five minutes to gather your things." We were walked four miles into the woods...about eight thousand people were gathered in this ghetto in the forest. We slept outdoors. I survived.

My police captain would drop bread off for us. We were there for three weeks. The captain offered to help get me and forty others out. My mother wouldn't go. I couldn't leave her. Then the ghetto was liquidated. We were shipped in June by cattle car to Auschwitz. The family got separated. I survived, but my mother, father, one sister, and two brothers were sent straight to the gas chambers.

I was shipped to Riga in Lithuania and worked in a factory for a few days, then moved to another labor camp. I survived. We were liberated on 21 January 1945 by the Russians in Estonia. They were like animals. We escaped our liberators and walked home to Hungary, sleeping during the day, running at night... from 21 January to 17 March we walked. I survived. I came to America by boat and met my husband in 1952 at a Purim party. I told him marriage is a fifty-fifty arrangement. "As long as you relinquish your fifty percent we'll have no problems," I said. Now after forty years, he says he wants to renegotiate the contract and get back some of his rights...I'll think about it.

My children are my life. When I think of what I went through in Europe, I wanted to give my three boys whatever I had. We lived in a one-bedroom apartment, but I sent them to the best private Jewish schools. And then all three were sent to the best law schools. My sons all have some of my stubbornness and determination. They are all successful lawyers. I wanted to be a lawyer when I was young. Now I'm proud to say I've got three of my own.

Nothing came easy. We worked hard to raise our sons. Education is very, very important. I'm attached to all my boys. I still think of them as my babies. They don't want to be treated as babies anymore but that's too bad...it's my right to spoil them. It's hard to let go. I never will. They'll always be my babies no matter how old they get. I am alive to see my grandchildren... I survived.

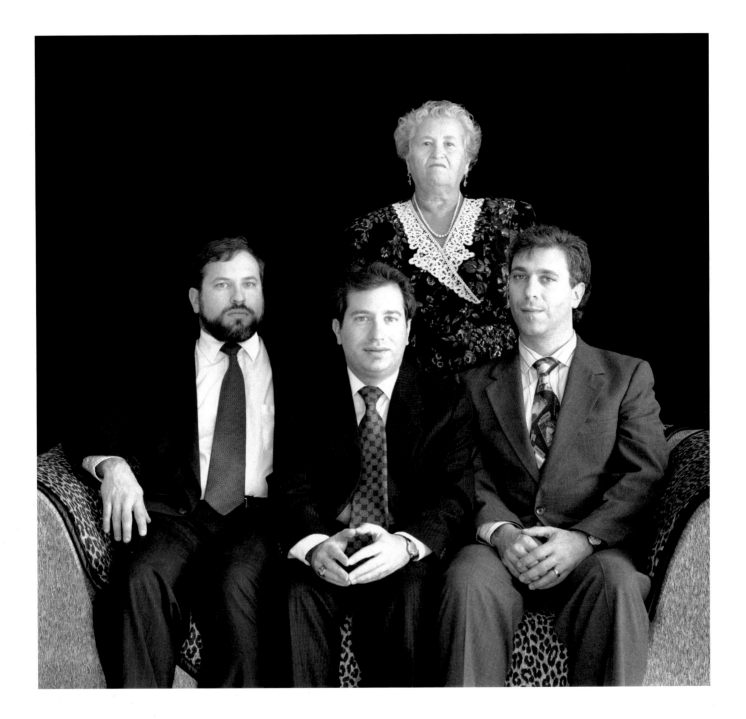

COOKBOOK WRITER **SIMONE MORAND** [*and*] **YVES PETIT DE VOIZE** MUSIC PRODUCER, EDITOR,
AND PIANO TEACHER AND ARTISTIC DIRECTOR

Paris
1985

SIMONE MORAND You might have been a pianist, for as a child you were not the least gifted of my students. But composing impossible toccatas—I had to decipher them on the spot—was much more your thing. Leaving our beloved Brittany for Paris, you flung yourself with the same creative enthusiasm into poetry and literature. Music didn't abandon you, though, since at the famous Épée de Bois Theatre you wrote incidental music for the plays by your friends Jean-Paul Aron and Kateb Yacine, the great Algerian writer. After the rehearsals, Yacine slept in his clothes and shoes on your floor, rolled up in a bedspread.... Those were the days when each neighborhood of Paris was still a village. I was quite alone in Brittany and I missed our "four-hands" sessions, for your little sister had joined you in Paris to study dancing. A child prodigy of concert organization, at the head of a remarkable team of French musicians, you skimmed over France, creating festival after festival: Saint-Maximin in Provence, the Abbaye de Royaumont, Saint Paul de Vence near your good friend Aime Maeght, the Charterhouse of Villeneuve-lez-Avignon, and Les Arcs. Today, you are running the splendid Montreux festival, on the shores of calm Lake Leman, where I join you every autumn.

YVES PETIT DE VOIZE As far back as I can remember, music—not heard but played, sung, performed—exploded all over the house. Piano music, of course, with Bach and Chopin that you played so well. And there were also old songs, French or Breton, like that sad "Pelot de Betton" and "Hirondelle volaige," so sweet to fall asleep to, holding your mother's hand, lulled by her voice...

Without quite knowing what to do—piano practice bored me and there were too many books in the house, outside too much rain and wind—I knew already that music would be my life and Paris my magical point of attachment.

May '68 was my personal revolution; I ran from the occupied Conservatoire to the occupied Sorbonne, by way of besieged Odeon and the Renault factories. For a provincial petit-bourgeois, a nascent artist and politically quite unconscious, it was a great adventure to be out in the street ready to throw a cobblestone... somewhere. Writing it all to you was part of the fun.

Music tore off its penguin uniform to run out into the street and onto the barricades. I organized "wild" concerts for my young musical friends. Once "order" had been restored to the streets and the factories, some of us still didn't want to hear any more music in the dusty halls of the Salle Gaveau or the Theatre des Champs-Elysées. Besides, no one was asking my musician friends to play there yet! But I had got into the habit: I was the organizer [and the page turner] they needed. Thirty years later, I still am, but how bourgeois those young rebels have become! Only Beethoven, Chopin, Mahler, Schubert, Brahms, and Bartók have kept their old generosity and their freshness. Their music is still a miraculous refuge for me, in these disappointing days of music-as-merchandise, music-as-spectacle, music-as-furniture... This collapsible refuge, this portable cloud, this welcoming ether: I owe them to you. Your piano and your voice introduced me to them long before "showbiz" and "success" led me astray, far from our father Bach and our beloved Faure.

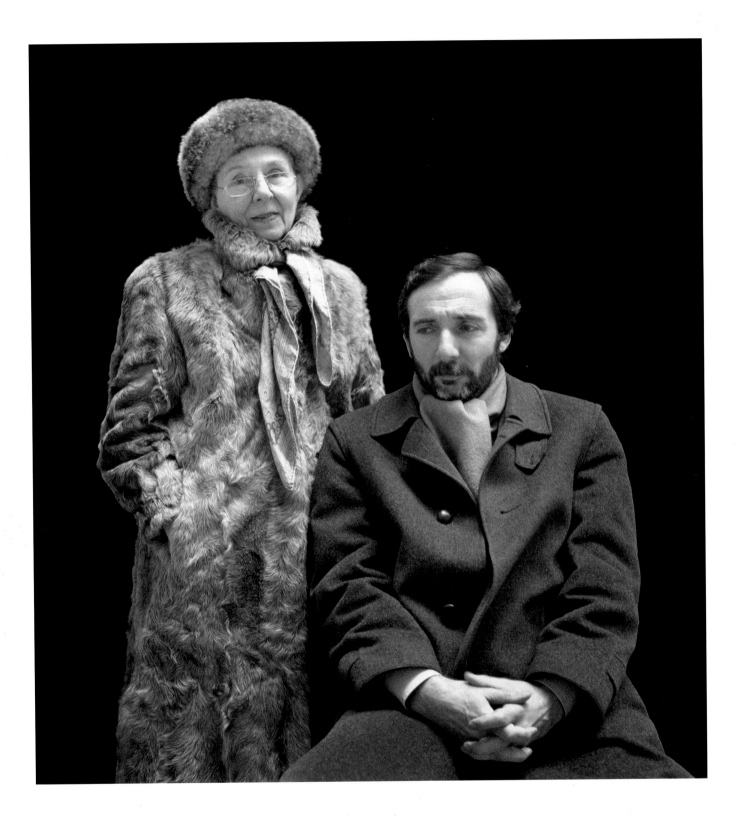

WRITER **BETTE BAO LORD** [*and*] **WINSTON BAO LORD** TELEVISION PRODUCER
Washington
1994

BETTE BAO LORD "I" is a word in the English language that I write most reluctantly. It smacks of egoism, the sin of sins that Chinese must avoid. Win is my flesh and blood, a part of me. He is, above all, my heart.

Don't get me wrong, he's no angel. An angel, especially one dwelling just a short flight downstairs from his elders, who could have in a blink programmed the clock on our VCR and our telephone for auto-dial and not have left his mother, me, seething for months, and seething still. Nor at twenty-seven and gainfully employed by Media Team to fly about the country helping political candidates, is he in any way a child. And yet, in an era in which the contented Brady Bunch seems as outdated as a brood of dinosaurs, he hugs his mom often and unbidden, with extinct ease.

At bottom, the word, "easy" suits him as comfortably as the clothes he exhumes from closets and trunks which, alas, are nothing to write about. But this past New Year's Eve, as chairman of the Millennium Society's annual scholarship ball, he had no choice but to forsake his normal attire. His parents—who, by the way, only received an invitation to this gala as the chairman was breezing out the door on the appointed day—were later rendered speechless by the ease with which their delinquent tenant sported the starched shirt, bow tie, and tuxedo and served up a whale of a good time for a thousand people.

Where did the years go? Only yesterday, in my silk gown and spiked heels, I was chasing after a four-year-old protesting his mother's departure, already delayed, by racing from one neighbor's lawn to the next attired in nothing at all.

What will the years to come bring? I cannot guess. But whenever my son and I are together, he will hug me. And I him.

WINSTON BAO LORD I can remember the last time I jotted down random thoughts about my mother. It was a homework assignment for Mrs. Hirschhorn's third grade class. Then, the words flowed freely and easily. "I love her," "She's pretty," "I admire her," "She's the best mommy in the world," etc. Today, those sentiments have only intensified. So why am I awake at four a.m. trying to capture and commit those same feelings to paper now? My mom would claim it is the procrastinator in me. I think it is my fear of being simplistic. Yet, although our relationship has grown more complex in the intervening twenty years, I can think of no better words to illustrate my feelings towards Mom.

Sure, we've certainly had our share of disagreements. But I've grown to realize my mother has always had my best interests at heart. I will never forget the first time I heard my father swear. My mother was insisting on banishing me to boarding school, despite my father's vehement protests. She won. At the time, I thought my mother didn't love me. I thought she just wanted to get rid of me. Now, I realize it was probably one of the toughest decisions she has ever made, but made for one reason and for one person only: me.

My mother's selfless manner extends far beyond the boundaries of the nuclear family. She touches so many lives, not just with her writing, but also with her warmth and compassion. Throughout the years, I've witnessed her passion restore an American artist's dream and nurture the budding career of a Chinese opera singer. These and countless other unheralded actions truly reveal her character.

Despite my mom's relentless chiding for eating too quickly and talking too much sports, I do not hesitate to use a phrase that up until now I have reserved for only those of my generation: She's one of my best friends.

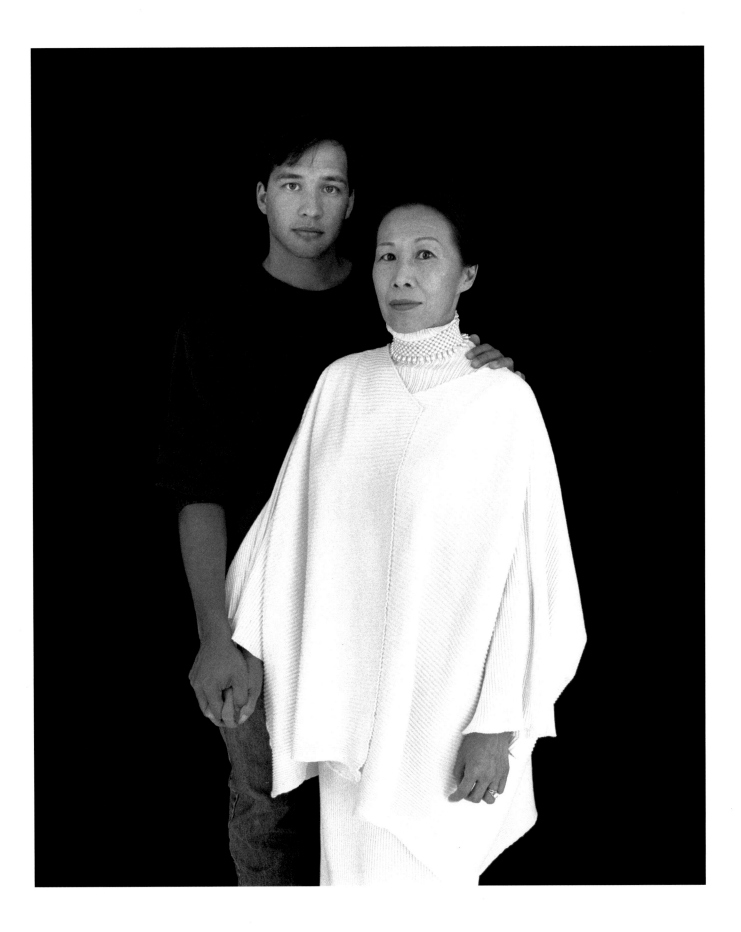

VOLUNTEER **NANCY ADLER** [*and*] **ROMAN ADLER**
Ross, California
1994

NANCY ADLER It is easy for me to see in Roman his father's characteristic traits. Kurt died when Roman was just five. They do look alike but I cherish most the subtle similarities; the disarming, devilish smile [which is captured in this photograph]; the delicious charm; and the skillful ability to solve problems and negotiate. And yet, regardless of his genetic inheritance, Roman is wonderfully his own person.

From the very beginning he has known who he is. Good-natured, open and engaging, he is easily respected. Generous of himself, he is a leader and despite his young age, my trusted friend.

Roman and I share a powerful bond. How does he know me so well? How is it that we don't need to speak in order to understand each other? How can he know when I need a hug? Why is he not embarrassed to reach out and squeeze my hand no matter who might be watching? Quite simply, he radiates a warm feeling from which I draw strength and courage.

Whatever the future brings, my greatest joy is knowing that we will always share this deep love and oneness...no matter how many times he kills me playing "One-on-One."

ROMAN ADLER I am at a loss for words when I come to describe my mom. She has so many different qualities and traits. She is mostly a warm and loving housewife, but that is not all. Ever since my father died she has tried to fill in for some of the little things that do add up in a young man's life. Those catch games, father-son outdoor trips, and how to catch a football. I always see my friends pitching to their dads down at the local field and I think to myself how much time my mom has devoted to my life. If I am sad or depressed, she is always there to help me get through.

Setting: The Drive-Thru
"What would you like?"
"Well, um, er, I think maybe a #3 with yuk."
"A #3 with milk?"
"No, no yuk."
"Coke?"
"Yeah! Yuk."
"That'll be $4.38 at the window please."
"Wow, I hope I have that much."
"I hope so too, ma'am."
"Well, guess we'll talk to you next time. Bye, bye, now."

Sometimes I feel sorry for the people at McDonald's...but by the time I could try to stop my mom, Sabrina [my sister] and I would be laughing so hard in the back seat our eyes would be watering. My sister is a little embarrassed by this, but I think that Mom is just trying to make us laugh. This is what I believe is just another sign of her love for us. I now remember all the times that she has tried so hard to make us happy and if she ever fails it won't matter because she is the most loving, sweet, kind, and definitely the funniest mom a guy could have.

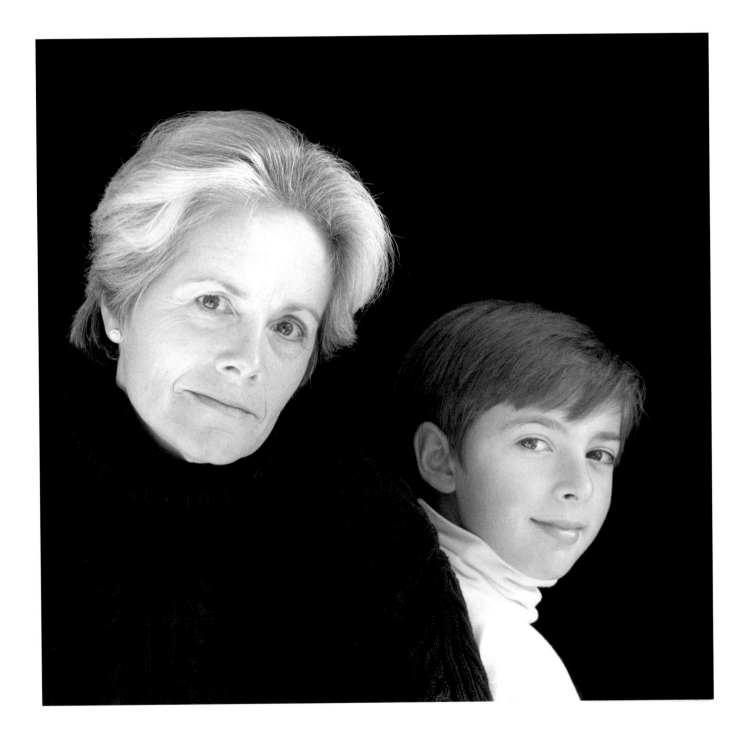

NEWSPAPER PUBLISHER **KATHARINE GRAHAM** [*and*] **DONALD E. GRAHAM** NEWSPAPER PUBLISHER

Washington
1994

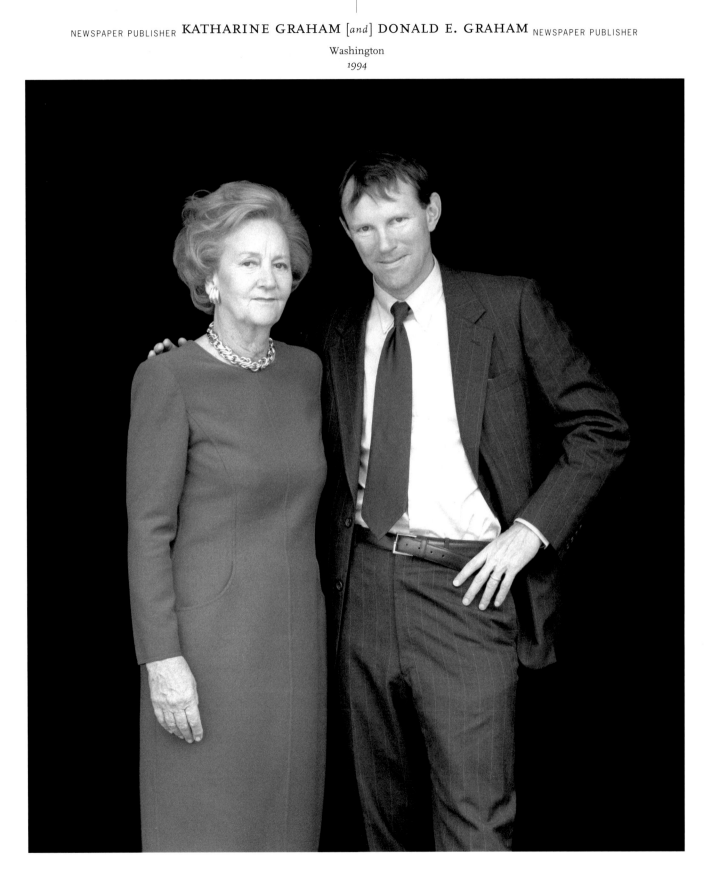

TELEVISION PRODUCER **SHAMANEE KEMPADOO** [*and*] **MARIS DIE PRAAM**

Amsterdam,
1993

SHAMANEE KEMPADOO Having been raised in a family of women, by a mother whose existence was centered in motherhood, I assumed that I too carried that gift within me. Impatience gradually slid into a monthly spiral of grief. Then came the longed-for conception, only to end in the pain, the unfair pain of an ectopic pregnancy.

The following empty year, the world seemed to consist of sisters and friends gently parading their offspring or sailing their huge bellies past me. I resented my body which had betrayed me.

The option of trying in-vitro fertilization put me in a state of panic. It took a year to be able to make that decision. And then another year and a half on the waiting list. In retrospect, that time gave me the ability to begin the IVF process with something like resignation, in harmony with my husband, no longer raging at the world. This is our son, Maris.

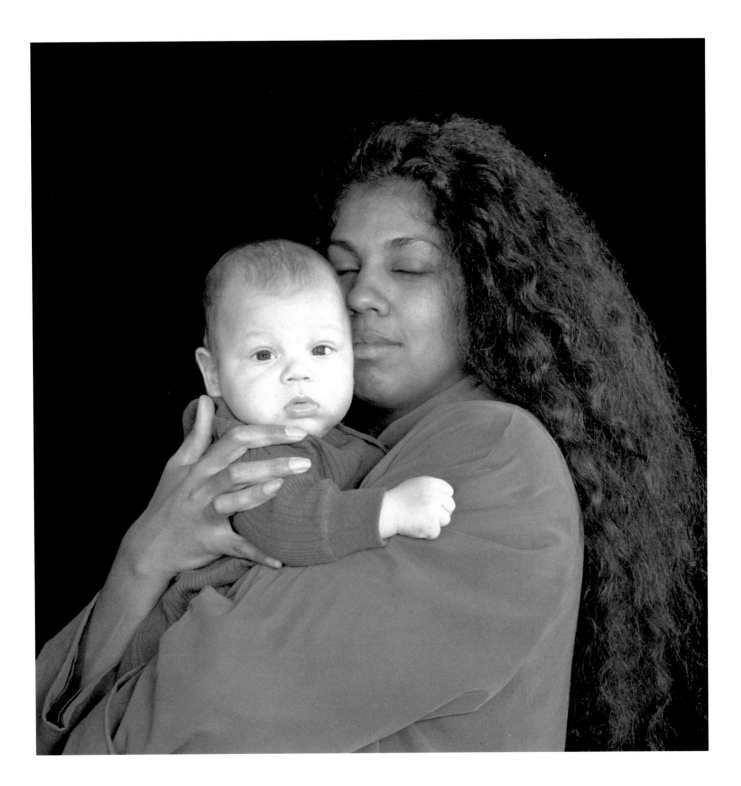

FARMER'S WIDOW **GENEVIEVE FOLTZ** [*and*] **ROBERT FOLTZ** FARMER

Shelbyville, Indiana
1994

ROBERT FOLTZ Having grown up on the farm, I see myself as being pure country. Thanks to my mother I value my life on the farm and am proud of my heritage. I've seen my mother sacrifice a lot of herself for the farm. A lot of her needs came last.

It was a simple life; a Quaker religion with simple beliefs. We were not always the first to have material things. I remember her hanging clothes out on the line year after year in the dead of winter. I believe one of my greatest gifts to her was when I was around sixteen years old. I took the money I had made on my Four-H products and I bought her a clothes dryer for $212. Mother was the one I talked to as I grew. She stirred my love for fried chicken and peanut butter cookies. Hers are the best.

As I have entered my adulthood, married and had three sons, she has always been supportive in my progress and shares in things that are happening on the farm. She talks to me about her travels in her golden years as we ride in the combine. I hope to be as healthy and active in my senior years.

GENEVIEVE FOLTZ Since I was brought up in a home where my parents very seldom expressed or showed their feelings toward me, it has always been difficult for me to say and show how much love and affection I have for my son and daughter.

My son and I have always been close, and since we lost his father a few years ago, he has been there for me even more. It is always a pleasure to visit his home. He has a wonderful wife and three great sons. In the fall of the year, I always look forward to visiting at the farm and getting to ride in the combine when he harvests the corn and beans.

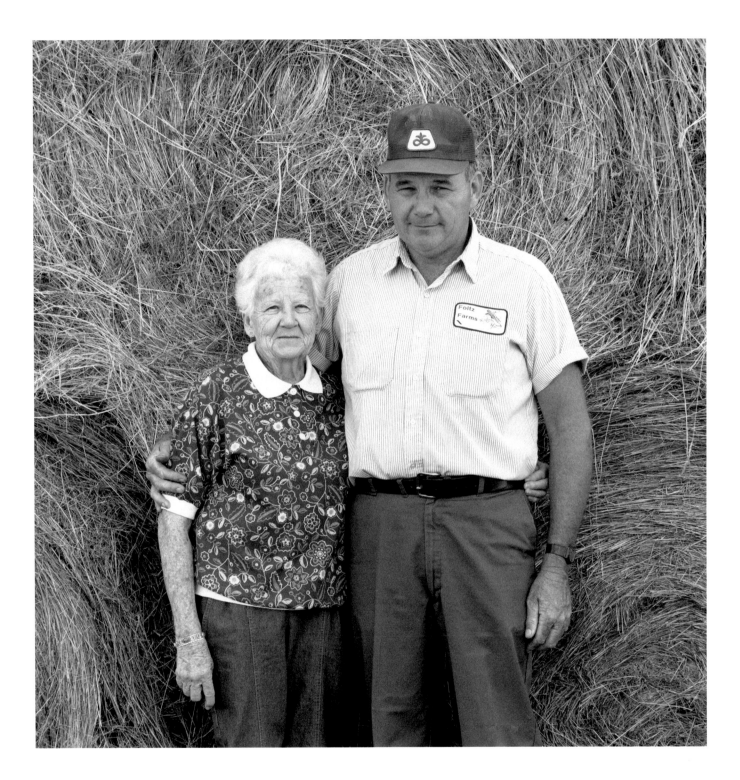

SUSPENSE WRITER MARY HIGGINS CLARK [*and*] DAVID RADIO PRODUCER AND WARREN CLARK JUDGE AND ATTORNEY
New York
1995

MARY HIGGINS CLARK I guess I was born with the maternal instinct full-blown. When I was little, I had a family of dolls that grew in number to the point that every night I tucked thirteen of them in bed. My ambition was to have six children so that they could sit even on the bus. I was blessed with five: three daughters and two sons.

I've thoroughly enjoyed raising a family; even, God help me, when they were all very little and very close in age so that when one was teething, another was colicky.

Warren didn't permit me a decent sleep for the first two years of his life—he woke up four or five times a night. David was always a recipient of whatever foul ball or flying glass came within a radius of ten miles—a hard luck kid whom my mother put in the care of St. Jude.

Now everybody's grown up and they're my good friends as well as my offspring. Many a Sunday afternoon finds everyone over at my house and as I look at them all—my children, their spouses, and my grandchildren—like Cornelia* I can truly say, "These are the only jewels of which I can boast."

DAVID CLARK A typical morning of my childhood: It's 7 a.m., I walk down the stairs to the familiar sound of tapping typewriter keys. In the kitchen is Mother. She happily announces "Five pages done, ten more planned, and the French toast is almost ready." Within an hour all five children are off to school, and Mother is racing for her car pool, still intently planning the ending of her latest short story.

I don't think we realized when we were growing up what fine mysteries were plotted and written at our kitchen table, but we all knew Mother was a good writer. After all, who else could proofread a homework paper, spruce up a college application essay, and help write an entertaining "What I did on my Summer Vacation" report all in one evening?

Perhaps the greatest strength she brings to her family and to her writing is her confidence and persistence. That confidence faced its own greatest challenge in 1964, when our father died of a heart attack. My sister Marilyn was thirteen, my brother Warren was twelve, I was ten, Carol eight, and Patty just five.

Shortly after my father's death, Mother took a job writing scripts for a radio promotion firm. Soon she became involved in production and sales, and began a daily commute from our home in New Jersey to New York City. In 1970, to meet our family's growing financial needs, she and a co-worker boldly established their own company to produce syndicated radio programs.

The same economic considerations encouraged her to play for higher stakes at the typewriter. The early morning hours formerly spent writing short stories she now devoted to her first suspense novel, *Where Are the Children?* Despite occasional setbacks in business, a family tendency to broken arms, and the difficult transition to writing novels, her Irish optimism refused to be shaken. There was never a problem so serious that it couldn't be handled with her comment, "Someday we'll all look back on this and laugh." It is impossible to forget the feeling of celebration when *Where Are the Children?* sold for the huge advance of $3000. The party Mother threw must have greatly diminished her profits.

As if five children, a full-time job, and a new career as a novelist were not enough to keep her busy, Mother announced several years ago that she had no intention of being the only non–college graduate in the Clark family. The same dogged determination that powered her as a writer served her well in the classroom. For her children, the most memorable aspects of her college days were the courses that gave her difficulty. When a midterm exam in logic produced a failing grade, we saw an opportunity to return past favors and introduced drastic measures to help her. I confiscated the car keys. My sister placed severe restrictions on Mother's social life. My brother lectured her on the difficult job market she would face if her grades did not improve. Our "parental" concern paid off and Mother graduated summa cum laude.

*CORNELIA [MOTHER OF THE GRACCHI] DEVOTED HERSELF TO EDUCATING HER SONS TIBERIUS AND GAIUS AFTER THEIR FATHER'S DEATH.

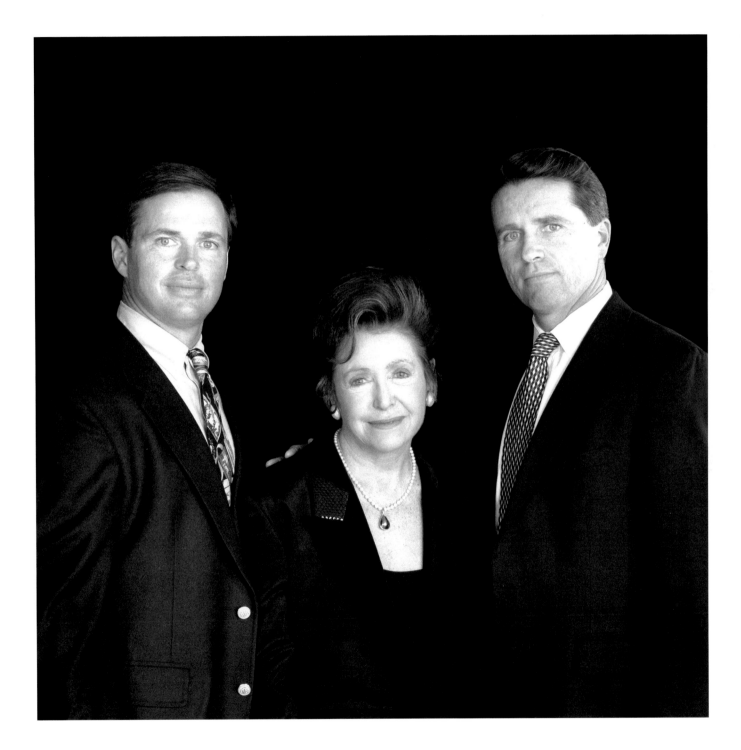

QUILT MAKER **FERA LEVITAS** [*and*] **MITCHEL LEVITAS** JOURNALIST

New York
1994

MITCHEL LEVITAS It dawned on me during my mother's ninety-sixth birthday celebration last year that she might go on forever. She had recently finished David McCullough's extra-large biography of Truman [sadly, though, I had to slice the binding into four sections for easier handling]; she sews crib-size patchwork quilts in complex, colorful patterns that warm dozens of infants and children from coast to coast; she rarely watches television, even the high-minded "educational" kind. [On *The MacNeil/Lehrer Newshour*: "They take themselves so seriously."] And she doesn't even wear glasses.

FERA LEVITAS I always appreciate Misha's attention [he calls himself Mike] and prize the fact that he treats me like a person, not just a mama. We argue sometimes—both of us are strong minded—but argument serves to keep us together.

I can't get to the library, so he supplies me with books. Even when I don't like a book I try to finish it to find out why I don't like it. I generally read two or three books at the same time. Misha also finds customers for my quilts because he knows that making them gives me great pleasure. Being idle I regard as the worst punishment.

I think I still belong to the world because of my son.

With the shrewd good humor of a lively storyteller and an attentive listener, my mother is rarely bored by other people, though she can make tough judgements on some close friends. Arthritis has slowed her down, but the pain is something to be endured, not complained about. It's not stoicism, exactly; more like an acceptance of the inevitable that serves to conserve emotional energy. Her secret lies in a determination to keep pushing herself to do things—read, travel, go to a small party—even as the limitations of age make the pushing more difficult.

Often, in closing our telephone conversations, my mother says, "Well, keep going." "You, too," I reply, but I don't think she depends on the encouragement.

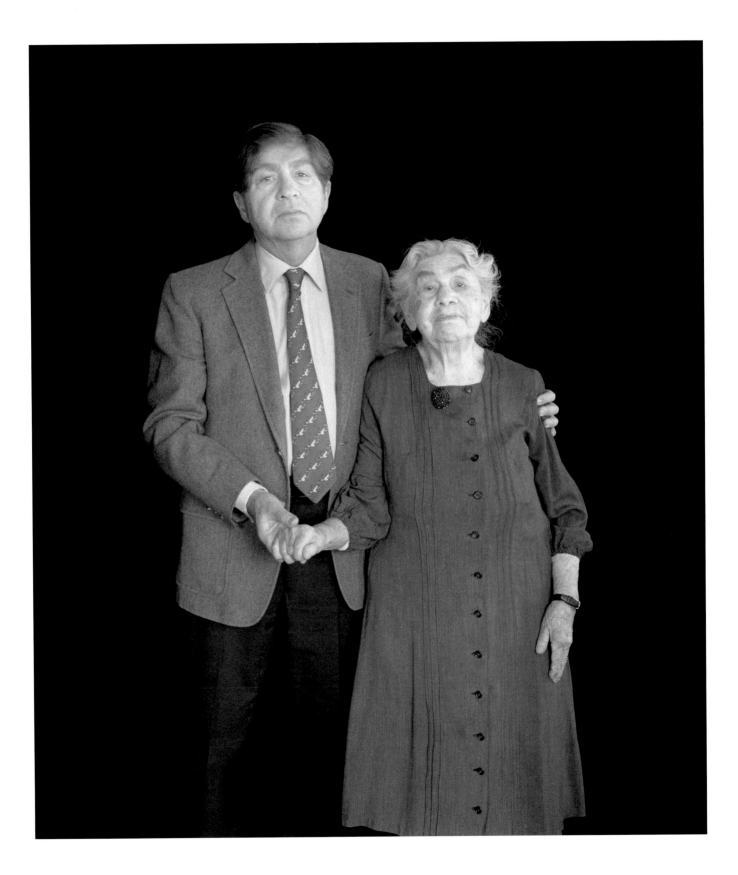

HOMEMAKER **ROSA DIAZ** [*and*] **GERARDO DIAZ** CHARRO PERFORMER

San Antonio, Texas
1994

ROSA DIAZ November 7, 1960, was one of the happiest days of my life. My first son was born, Gerardo Carlos Diaz. My husband José and I enjoyed him growing up by his sister who is two years older than him. He was a very happy and active son. By the time he was able to sit on his own, at about four months, his father would put him on the horse and tie him to the saddle and both would go out for a ride. At the age of nine months he was walking and already had a rope in his hands trying to lasso and breaking things. Before he reached two years old his father would take him on the weekends to the ranch to ride and learn how to take care of the animals and of course a rope was with him at all times. He learned to maneuver the rope at an early age. He was a very giving person and would invite his friends to the house to play and would ask me to cook for them. He was so giving that one day he stopped the ice cream truck and told the man to give all his friends some ice cream, and he paid with play money, so mom goes to the rescue. I smiled and was very touched by it. I taught my children we must give to receive.

Now my son Jerry is a professional entertainer. He has been able to reach all his goals as a performer and his performances have continued to expand. I as his mother have seen my son grow, as a man and as a leader to the younger generation. It is like a dream to me and it fills my heart with joy to sit in the audience from small performances to large productions to feel the vibration in his heart and to see his dreams come true. My son is very proud to carry on his father's tradition as a horse trainer and performer and now he is producing and directing major events. Jerry has received another gift from God, and that is everywhere that he travels the young boys and girls look to him like their idol. I've seen my son in good times and in bad and he has remained the same positive person, always committed to go forward. I am very blessed to have a son such as himself and I wish him all the best from the bottom of my heart, and may God bless him always.

GERARDO DIAZ What can I say about my dear mother? My mom's name is Rosa Guajardo Diaz, born in San Antonio, Texas, of a family of thirteen. My mother married my father, José Pepe Diaz from Guadalajara, Jalisco, Mexico, in 1957 in San Antonio, Texas. This celebration was done all in Mexican attire, with carriages and *charros* in a traditional Mexican atmosphere.

My mom is a lady that believes in prayer and has deep faith in the Catholic church. My mother prays every day and has made a lot of unbelievable things happen. She never amazes me. She is the backbone of the family, always supporting all of my father's wishes and needs, looking after my sister, Martha, and her children. We live on a small ranch in San Antonio, *Charros del Bajio*, a horse-training operation. My mother enjoys feeding the horses and always caring about the operation. While we are out working horses, I see her walking around the ranch looking after my father and me. She is constantly worrying about us. Not only is she my mother, but she is always answering all my business and personal phone calls. Everybody that speaks to her on the telephone gives me great compliments that she sounds like a beautiful person. Not only is she a wonderful mother but she is a fantastic cook. I always have to be watching my weight.

My mother suffered a severe stroke in June of 1988 which made me understand how much she really means to me. Her strong faith and prayers have kept me going and have continuously answered all of my problems. I've always admired my mother for her faith and strength; she is absolutely wonderful. My mother is a very happy, jolly, and outgoing person who does not ask for much but is always giving a lot. I can always depend on her in the hardest times and moments in my life, no matter the situation. She gives me her blessings when I go out on rodeo and performances and in all my travels. I always feel secure when she does this, especially when the pressure is on. I hope to have my mother next to my side for many years to come. Mom, I will always love you.

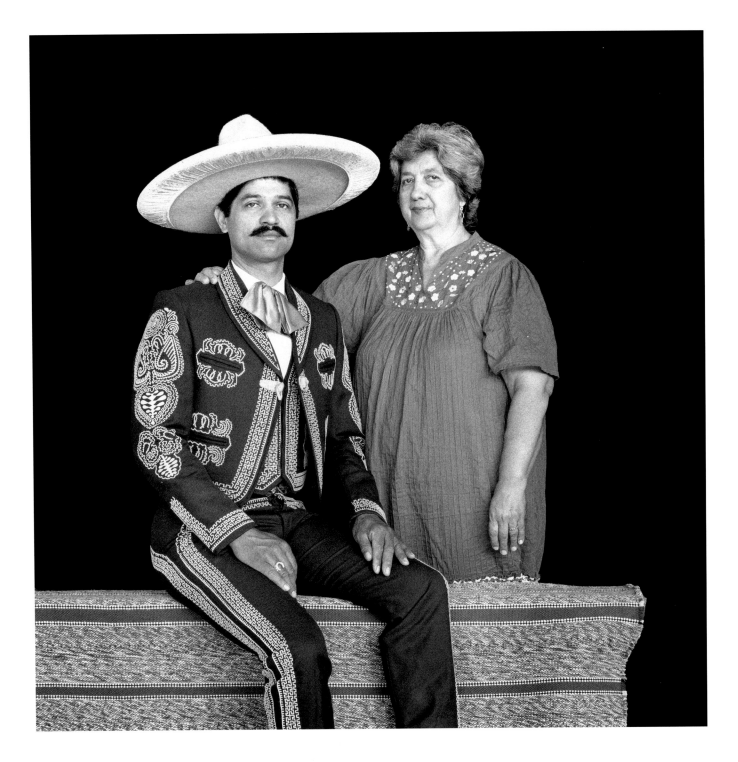

BOOKSHOP ASSISTANT **ALEXANDRA CROSS** [*and*] **T. PETER KRAUS** BOOKSELLER

New York
1994

ALEXANDRA CROSS My life has been like Caesar's Gaul, divided into three parts. The first part was spent in the spa town of Carlsbad in Czechoslovakia where my parents owned a hotel with an international clientele. When Hitler's troops moved in, I moved out and spent the next thirty years in England. Shortly after I got there, I married my childhood sweetheart, a plastic surgeon named Anthony Kraus, which we anglicized to Cross, who was also a refugee from the Nazis. We somehow survived the war despite being bombed out three times, and shortly after the war ended, our only child, Peter, was born.

Peter arrived equipped with two small sharp teeth which I found rather painful, and others found quite unusual. He was barely able to walk when my husband was hospitalized, but luckily the widow of a local doctor took us in and between the two of us we brought Peter up. We called him "the little horror." He always seemed to be up to something and one of my earliest memories is of the local bus driver refusing to take him to kindergarten because he ran up and down the bus instead of sitting down. It was not easy bringing up a child in a strange [but far from hostile] country and despite the disapproval of many of my friends, I always let Peter know exactly where we stood and how much or how little money we had. I think this gave him an early sense of responsibility and it gave us a shared sense of purpose as he was growing up.

T. PETER KRAUS My mother is a very special person. Life has played many cruel tricks on her, yet she remains undaunted, and always radiates an air of unbounded optimism. Shortly after I was born, my father was hospitalized with a nervous breakdown from which he never completely recovered. Thus my mother found herself in a foreign country [England] to which she had fled when Hitler annexed her native Czechoslovakia, with a small baby and no visible means of support. Apart from a short stint at medical school, she had no qualifications for any form of employment, yet somehow she managed to find all sorts of odd jobs, and managed to support the two of us and later her own widowed mother.

My mother has always had the ability to make and keep friends with people of all generations. She now has friends all over the world which is also a tribute to her unselfishness and her generosity. She would always think about what she would have to give others even when she had next to nothing herself. At the age of sixty, she emigrated to America to help me run my book business and to embark on a new career as a granny. Once again she did all sorts of jobs, from typing invoices to bidding at auction. Over twenty years later, she is still at it, having become den mother and friend to a staff of twenty, listening to their stories and sending them cards on special occasions. From as early as I can remember, and even today, we have discussed everything and woe betide me if I forget to bring her up to date on any detail of either family or business life. Her circle of friends is still growing, but firmly rooted at the center are a devoted daughter-in-law, two adoring granddaughters and a son for whom she will always remain "the best."

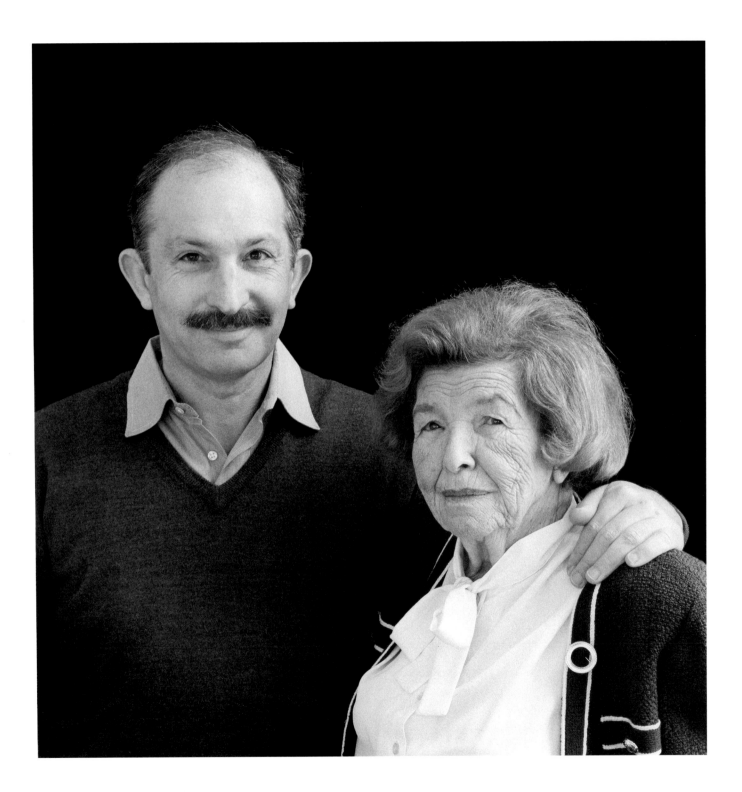

TEACHER ELAINE COOK [and] JIMMY AND FREDDY COOK

Los Angeles
1994

ELAINE COOK I've always been happy to have sons, even with the recent birth of my third. I'm very glad it was a boy. I think the most surprising aspect of having boys is how sweet they can be.

My boys are always thinking of each other. When Jimmy and Freddy were young, they assumed every boy had a brother. When they saw a picture of two boys together, they never even considered that it was a picture of friends; they always saw it as a picture of brothers. Those close ties make me feel very successful as a mother.

My eldest son, Freddy, was born with Down's syndrome, which took us all by surprise. It was an eye-opening experience. I had never imagined anyone needing me as much as he did. It seems alien to me now that the very capable young boy I have, as a baby took three weeks just to learn to suck on his bottle. I had no idea of what to expect. Nothing comes easily to Freddy. He is a testament to self-determination. I saw his arrival as an opportunity to be a part of something greater. I put aside professional ambitions and focused on giving Freddy the nurturing and support he needed to thrive. I would love to take credit for his great accomplishments, but the hard truth is that he achieves what he wants to achieve and any successes he has are his.

My boys are very different people. This year Jimmy is in the first grade. He loves school and is pretty bright. Whenever he's faced with new situations, he always turns them into successes for himself. One day, his teacher and some student teachers were doing an activity in the classroom on the five senses. After the lesson, they asked, "What are the five senses?" Jimmy answered the correct five senses but told them there was one more they had forgotten. "What sense is that?" the student teachers asked. "The most important sense of all. The sense of humor," answered Jim. The whole class and the teachers laughed. Jimmy quickly replied, "I'm glad to see you all have one."

It can be hard to watch two such different people go through life. It seems as though Jimmy has it a lot easier than Freddy. They are both kind and loving to their young brother Thomas, who is not to be overlooked. We're very lucky, my husband and I, to have three such wonderful people to spend our time with.

JIMMY AND FREDDY COOK Mommy is a lot of fun. We don't know of any other mom who will do so much with her kids. Our mom always had time to read with us, do math projects with us, do art projects with us, rollerblade with us, play soccer with us, play baseball with us, boogy board with us, surf with us, play computer and video games with us, and make great meals.

Mommy is an artist and weaves beautiful things. Even right after she had our new baby Thomas, she still made time to come into our classrooms several times a week and weave with everyone in the class.

We love Mom very much. She makes us feel really special. Oh, Dad, we love you too.

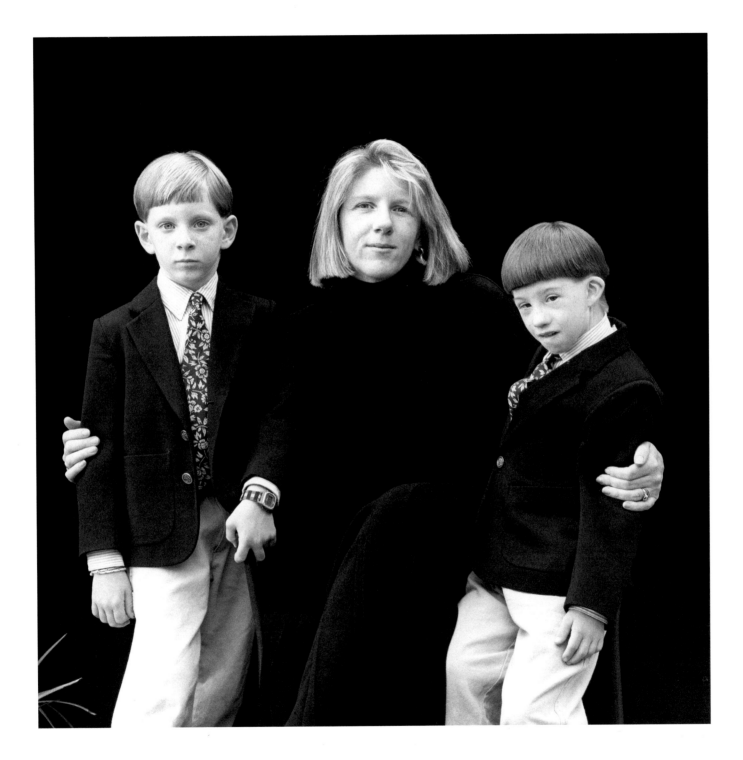

MUSEUM CURATOR **JUDITH KELLER** [*and*] **RUSH CLINGER** MUSICIAN

Austin, Texas
1994

RUSH CLINGER My mom and I are friends. We spend our time together going on walks. Usually we hold hands. We walk through bookstores and museums. We walk to the theater and watch a film we have both been wanting to see. We give each other glances and subtle smiles; we never discuss them because we know what they mean.

It's hard living in this world with the ways my mom let me grow up, being antisexist and antiracist and politically radical. You have to be strong and willing to be right and to be wrong. Leave yourself open to new ideas, be creative, learn how to listen: My mom taught me that. Strength comes from love, unconditional love, not faucet love that can be turned on and off or even turned down or left dripping. There is a certain freedom that comes from knowing you're loved. What you know is always with you whether you need it or not.

I am very proud of my mom and her work. I have watched her persevere and she is a star in her field. I would like to protect my mom from life's harsh realities. And I know I can't. And it's okay. I love you, Mom.

JUDITH KELLER Although I have written a lot about photographic portraiture, I was not prepared for my own intense response to this representation of me with my only child, Rush. For reasons I could not at first understand, it upset me a great deal. I slowly realized that it reminded me, painfully, of a time more than twenty years ago when my son and I were suddenly left alone. I don't think either of us has yet recovered from that experience.

It was just the two of us for several years. And our relationship has continued to be a close one, in spite of the fact that I was always in school or at work during his childhood and Rush chose early independence, taking off for Europe at the age of seventeen.

I grew up in a family of girls, so my son has always been a marvel and a mystery to me. He is sensitive and wise and patient, but he is also tall and strong and passionate. His quick wit and attentive nature can be charming; sometimes his earnestness can be frightening. I'm sure there is much I still do not understand about how he grew up and why he chose to reject the academic life that surrounded him for so long. What I do know, and what I find reassurance in, is that his concerns are about people and music, rather than money and things. Relative to mine, his is an existential existence that does not revolve around owning and accomplishing.

I am afraid I taught him very little, but I think I am still learning from the man—my son. It is hard for me not to think of him as a boy. No matter what his age or size, I will always feel protective of him, and he of me.

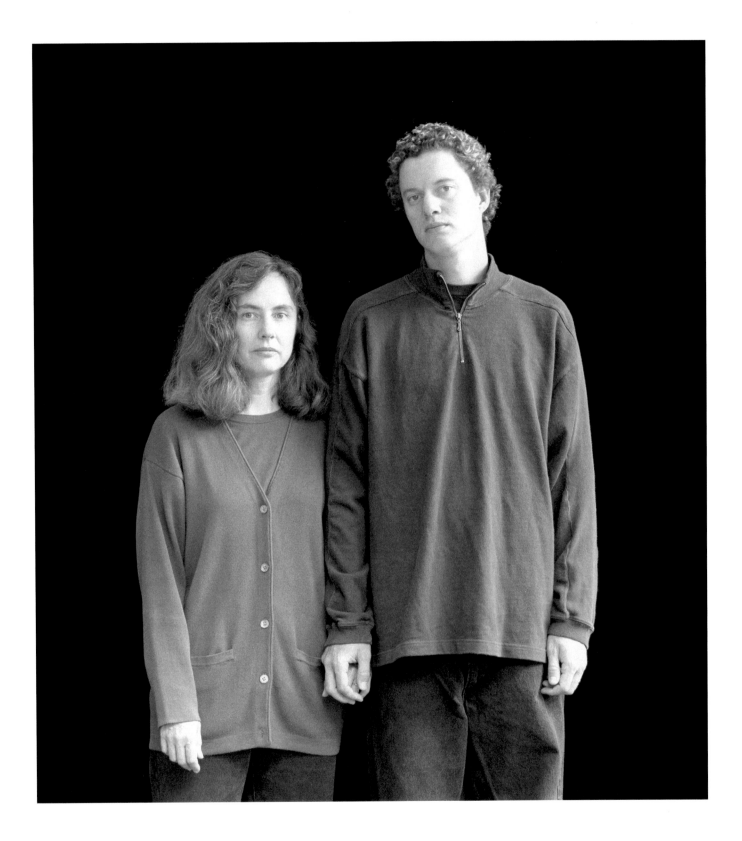

NOVELIST **SARAH BIRD** [*and*] **GABRIEL BIRD-JONES**

Austin, Texas
1994

SARAH BIRD I suppose the moment of maximum political incorrectness came last Saturday at that commercial shrine to all that is right-thinking and green, The Nature Company, when my four-year-old son, Gabriel, strafed the baby dolphins in the computer-generated video with his toy Uzi.

A woman standing behind us pulled her own children away as the frolicking Flippers ate hot lead. I imagine that this woman was probably the sort of mother who had a bumper sticker like the one I had scraped off the back of my own car when Gabriel was eighteen months old: "Don't Encourage Violence. Don't Buy War Toys." I imagine that she was the sort of mother who had successfully banned all implements of destruction from her house. You know the sort of mother I mean. The mother of daughters. Or the mother of a son who obsesses about Thomas the Tank Engine rather than battle-axes, nunchuks, hand grenades and catapults.

My boy, however, came hard-wired for weaponry. His first two-syllable word, right after momma, dadda, and backhoe, was scabbard. Scabbard at eighteen months? Why did I ever bother resisting?

Why? Because in college, in the sixties, I started Damsels in Dissent, a group which counseled draft candidates to eat balls of tinfoil and put laundry soap in their armpits to fool induction center doctors. Because I believed that wars were a manifestation of testosterone run amok, much like the purchase of bad toupees and red Miata convertibles. Because I believed that white sugar, commercial television, and guns were afflictions of a sick society and that any child could be immunized against them *if only he had the right mother* to pass along her more highly evolved antibodies.

Parents do not, indeed, live by bread alone. We feast daily on banquets of our own words. My child had never seen an adult touch another adult in anger; he has never been spanked; he has never even watched a Ninja Turtle cartoon—yet he is as bloodthirsty as Quentin Tarantino.

In his toy bin are half a dozen Ninja Silent Warrior Assassin swords, two scimitars, three buccaneer blades, two six-shooters, four Laser Fazer stun guns, a Captain Hook flintlock, the aforementioned Uzi, and

GABRIEL BIRD-JONES I like mom because she gives me Apple Jacks and we explore and find specimens. My best specimen was a deer antler, but I found the spot before mom did. Before anyone did. And there was also moss and a blue jay feather and other stuff too numerous to mention. And I like my mom when she screeches the car. You know, when the light is red and then it's green and I say "GO!" and she screeches the car. And she smells like cherries which I like. If she was a manatee and I was a baby manatee we would go in the deep blue Atlantic and see flying fishes and fairies. And that's all I have to say.

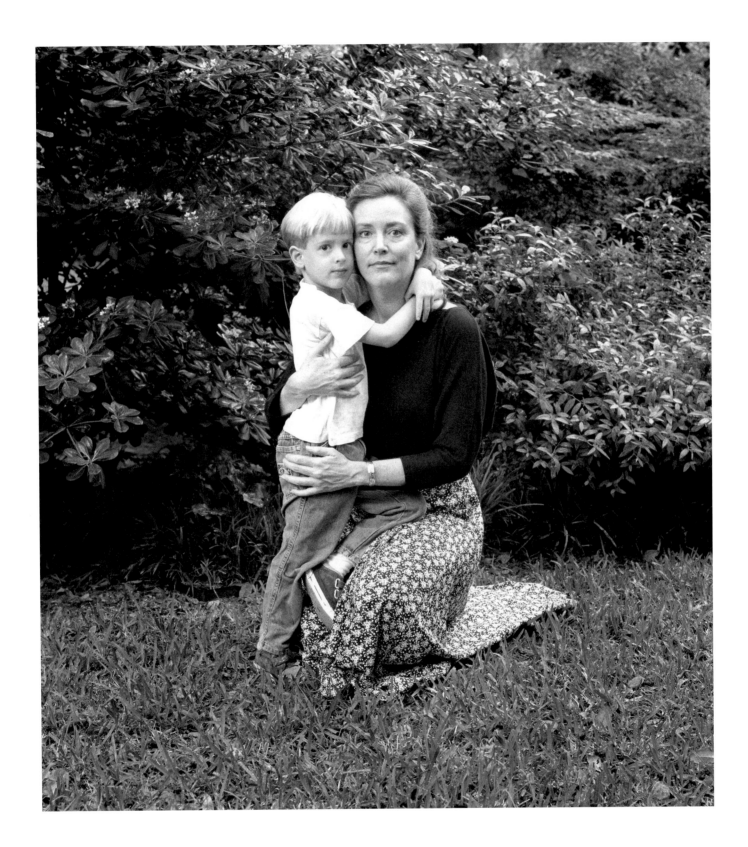

a silo full of items he manufactures himself. This inventory is by no means complete. I have lost friends over this arsenal. They cannot allow their children to be exposed to such untrammeled barbarism. Friends? I have lost an entire self-image and my deep Jeffersonian faith in the infinite perfectibility of man.

I resisted at first, certain that if only I stayed the course I would end up with a gentle little boy who named his stuffed animals and found Beatrix Potter a bit brutish. And I was holding the line rather well, too, till he started sleeping with a shoe. Though never one to question too closely anything that encourages slumber, I did finally ask, why a shoe? He answered, clutching the tip of the shoelace, "So that when the bad things come in my dreams I can shoot them away."

"...when the bad things come in my dreams."

Zen monks could contemplate their koans for years and not come close to the transformation I experienced when my child aimed his shoelace at me. Children are small and weak. The world is big and scary. Gabriel's need to feel safe so outweighed my own need to feel morally correct that the contest ended. From that night, we began building the armory until we achieved the overwhelming first-strike capability we have today.

I know what drives this war machine. It's a discovery of my own that I call the "Q gene." The Q gene is that chromosomal imperative that compels little boys to pick up sticks and hair dryers; to chew their organically grown, whole-grain sandwiches into the shape of guns; to use whatever they can lay their murderous hands on, take aim, and commence firing: "Kyew. Kyew. Kyew." The Q gene.

And here is my awful confession. I passed the Q gene on to my son. As in male pattern baldness, I displayed none of the symptoms myself, but carried them from both of my parents. My father an Air Force officer, my mother an Army nurse—I am the daughter of two warriors. I reflect on this heritage as my son stands by a helicopter at nearby Camp Mabry. We have already examined the tanks and fighter jets parked on either side. Compared relative firepower. Discussed how each would fare in a battle with Tyrannosaurus Rex. But my son pats the shark's grin painted on the helicopter and announces: "This is the one, Mom. This one is the best."

Watching him calls to mind a photograph of my father taken in the late fifties. He stands before a plane with a shark's smile painted on it, just beneath the inscription: 6091st Reconnaissance Squadron. My family lived in Japan then, conquerors grinning into the last minutes of a doomed colonialism. The crew with my father have their arms thrown around each other's shoulders, as heedless and glamorous as movie stars, frat boys, R.A.F. pilots, any gang of young men who know they will never grow old, never die.

Thirty years were to pass before I learned what it was my father did when he left us for weeks at a time. He and his smiling buddies would fly their "birds" over Russia and wait to be chased back into American airspace to test Soviet response time. That was when I understood why my mother, alone with six children, would burst into tears whenever an officer in uniform came to our front door.

I watch my son stroke the shark's grin and I want to whisper to him: "It is evil. All these machines are evil. You must never think about them again." But it can never be that simple.

I hear myself sometimes, times like this one right now. I see myself the way the mother shielding her children from the sight of my son opening up on the baby dolphins must have seen me, and I feel like a shill for the N.R.A. My position is indefensible, illogical, inconsistent. But love makes intellectual pretzels of us all. It's just that I know, long before I would like, there will come a moment when I can do nothing to chase away the bad things in my son's dreams. Until then, if I can give him a shoelace's worth of security I guess I will.

Okay, so I caved in on the white sugar, the TV, the war toys. There is, however, one moral issue that I have not wavered, have not wobbled, have not waffled on. I swore before my child was born that I would never buy a certain particularly insidious toy, and I am happy to report that I have held that line. There has never been, nor will there ever be, a Barbie doll in my house.

ARCHAEOLOGIST **JEAN FRIENDLY** [*and*] **NICHOLAS,** FOUNDATION EXECUTIVE **ALFRED JR.,** CONSULTANT

AND JONATHAN FRIENDLY JOURNALISM PROFESSOR

Washington

1993

JEAN FRIENDLY I am very positive, often wrong but never in doubt. It runs in the family, mostly on the female side. Thinking that over, I realize my sons are positive, too.

Posing us around the card table sets the scene for this exercise. Jonathan and Nicholas still play with me, but Alfred Jr. won't as he says I dominate the game.

My three sons are very individual and always were. Alfred, the overachiever, was a hard act to follow. Jon was accident-prone and needed more stitches and casts than all the others. He's known as the "nice" one and comes by the title deservedly as he's family-oriented and thoughtful about helping everyone. Nick, being a twin and considerably younger than his brothers, has expressed himself differently. He is my sport, playing good tennis, golf, and the best bridge.

All three are wonderful to me in a nice irreverent way. The whole family gets along well together; five couples and sixteen grandchildren. Living in the same house for fifty-four years is a unifying force as they all use it as they did when we lived here together.

ALFRED FRIENDLY JR. Not only a frequent substitute for serious conversation, contract bridge also serves our family as a usually nonviolent release for various tensions. Those who play it best, however, extol bridge as a partnership game, and Friendlys tend to go their own way. That trait is probably inherited.

As a matter of preference, I play bridge with members of other people's families. As a matter of principle, I have not played bridge with my mother for a number of years. As a result, we talk more than we once did. Sometimes seriously. It could be that absence from the gaming table makes the heart grow fonder.

JONATHAN FRIENDLY My mother and I were often bridge partners because it was easier on the nerves than having her partner my father, a man of common sense who did not believe [as she did] in gambler's luck. My mother's bridge is intuitive, spontaneous, and committed only to those rules and conventions she can modify to fit the immediate requirements of the thirteen cards she has been dealt.

We played a lot of games as a family, with Scrabble and bridge coming to dominate. Since my father's death, the bridge has become even more part of her daily life. If things had worked out a little differently over the last ten years, we would have been like one of Anne Tyler's Baltimore families—a mother and three sons and bridge together two or three or four times a week. But my older brother, Alfred, the one without cards in his hand, took exception to mother's style, and anyway, I don't live in Washington as they do.

I learned from my mother that in cards—as in other practices—doing what is fun often trumps doing what is wise. I can't say what she's learned from me.

NICHOLAS FRIENDLY My mother was always a fast driver, but a very good one. She was well into her sixties before she purchased her first non-ragtop. My childhood memories are full of driving scenes. I remember traveling the highways of North Carolina and glancing over to see that Mom was driving at over a hundred miles an hour.

Once, coming home from camp in Vermont, we were trapped behind a slow-moving van. finally, Mother could take it no longer. With no room on her left to pass, she swung the car onto the shoulder and raced past on the right. As we passed I looked over to see that the van was part of a circus entourage and hanging out the side was this great grey trunk waving in the breeze. At ten years old I felt thrilled to have passed an elephant on the wrong side of the road.

I drove convertible MGs for years in tribute to Ma. When I was in college, I read a book by Walker Percy called *The Moviegoer*. The hero also drove an MG and described the total absence of malaise that driving a convertible along the Gulf Coast Highway achieved. I was struck with how perfectly this reflection jibed with the trips of my childhood. I can remember no happier childhood experience than climbing into the Olds, hearing the sound of the top go down, and settling back to enjoy an uninterrupted time with Ma on the road.

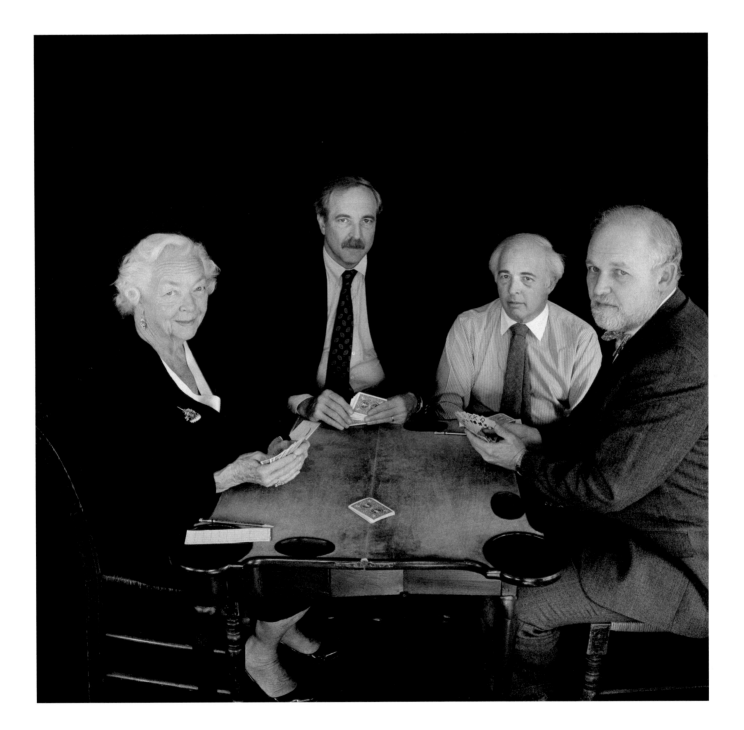

PUBLISHER **NAN TUCKER M^CEVOY** [*and*] **NION T. M^CEVOY** PUBLISHER

San Francisco
1994

NAN TUCKER MCEVOY

Someone to laugh with is one of life's Joys.
When that someone is your son, it's one of life's Gifts.

NION T. MCEVOY My mother laughs, her head thrown back. I smile. We must look as though we're sitting in the catbird seat, and for the moment, I suppose we are. But such things change, and that's not really what's behind our glee. It has more to do with what went on earlier: in the fifties, when we lived in Washington, D.C., and I was the only child of a working single mother; in the sixties, when I gave her an inordinately hard time, attracted as I was by everything new and dangerous; in the seventies and early eighties, when I distanced myself mentally, physically, and spiritually from her, as I suppose one must; and in the last ten years, when we've become close and learned to read each other clearly once again, much as we could thirty-five years ago, when it was just the two of us, arrayed against the world.

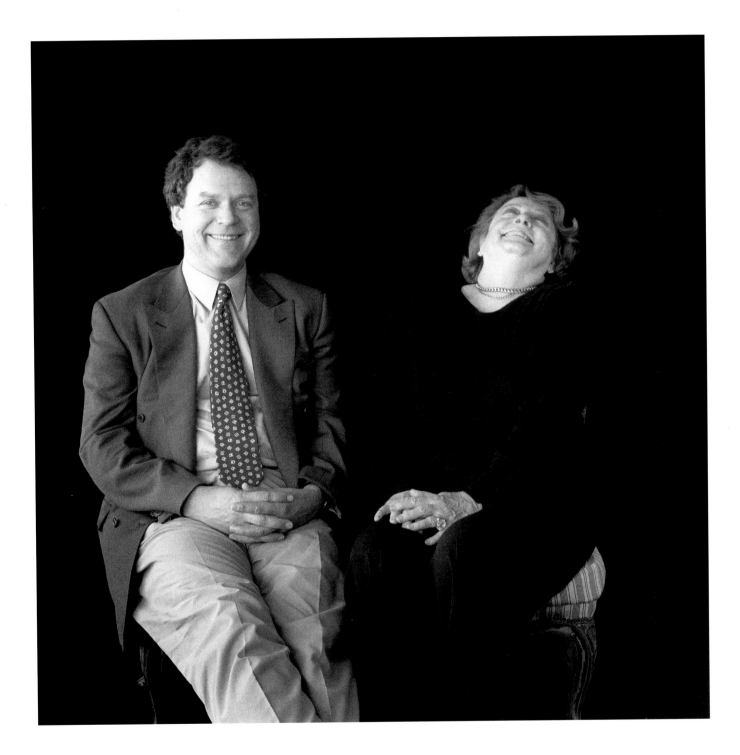

ARTIST **DORIS CROSS** [*and*] **GUY CROSS** PUBLISHER

Santa Fe

1993

GUY CROSS When I was a kid my mom was always wandering about in her basement studio in Brooklyn with a paintbrush in one hand, a cigarette in the other, and a phone tucked up against her ear and shoulder. She was always yakking on the phone and smoking up a storm while she painted. The smell of oil paints and turps still haunts me.

My mom was an extremely fierce, determined, and stubborn person. She was strong and demanding—not tolerant of laziness or procrastination from me in any degree. She was an abstract thinker, a marvelous critic of her peers, and she possessed an uncanny ability to cut through the crap, quickly.

Mom wanted me to live up to my "full potential," whatever that was. For years, I am sure that I failed her in this degree, despite my success as a commercial photographer. It was only at the very end of her life—about the time this photograph was taken—that she finally thought that I had "succeeded." I was with her the night before she died. She was very luminous—I knew it was soon. I asked her if she was still worried about me. She said, "No. I am not worried anymore." Then she touched my face with her hand and looked at me for a long time. She died the next day at high noon. Just like her. Bye Mom. And thanks.

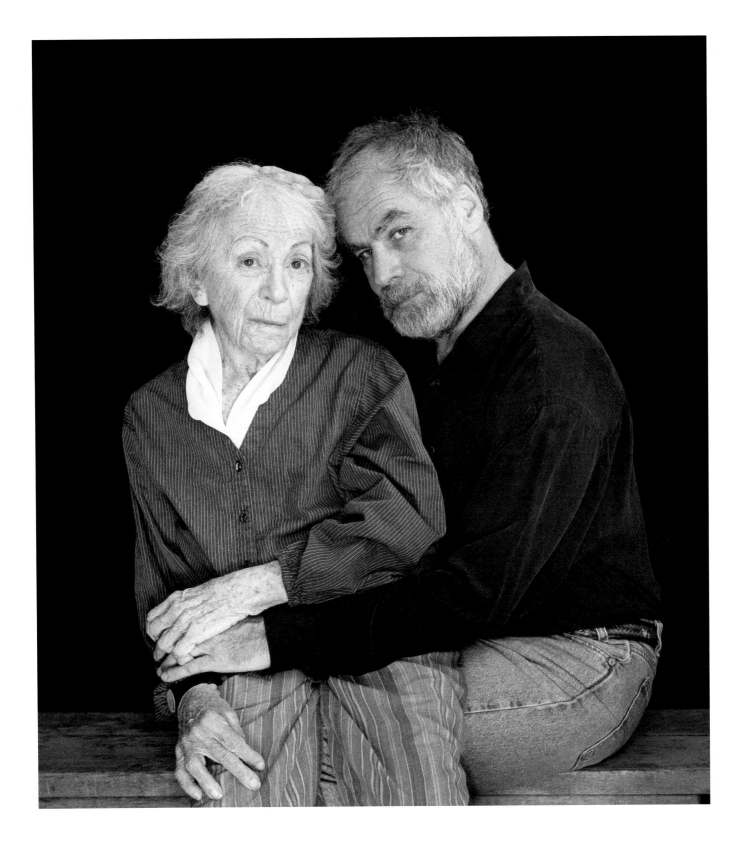

PROFESSIONAL MODEL **LAURIE WILLIAMS** [*and*] **ROBIN WILLIAMS** COMEDIAN AND ACTOR

San Francisco
1994

ROBIN WILLIAMS My mother was my first and toughest audience. You know with mothers you have to "work the womb." Our connection was comedy. We're closest when we laugh. It's like Lenny Bruce once said, "Most comedians are driven by 'Love me!'" and mothers are the source.

LAURIE WILLIAMS Robin was a delight as a child—and still is as a man. He was kind, generous—and, yes, funny. Not long ago, a friend of mine reminded me of how Robin would imitate the people in the line at the checkout counter when we were at the grocery store, or, when we had parties how he would imitate the guests after they left. Conversely, he was also serious: a top student and a good athlete—running, soccer, tennis. He worked very hard at whatever he did. Robb [his father] was the fair but strict disciplinarian, and I was more the playmate. I am immensely pleased with his success and also very grateful.

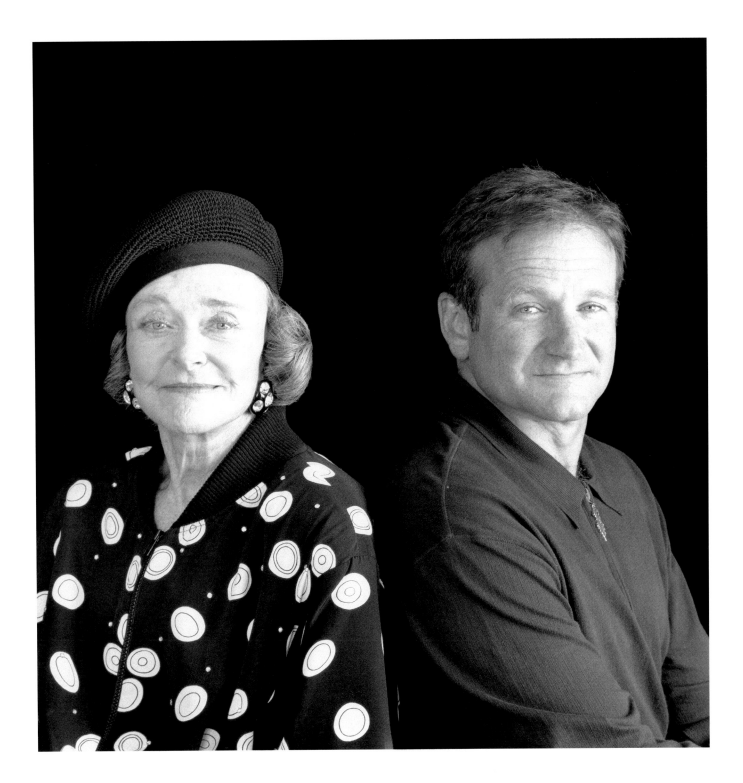

FLUTIST SUSAN ROTHOLZ [*and*] DAVID ELI AND DANIEL ROTHOLZ BAILEN

New York
1994

SUSAN ROTHOLZ I remember clearly how my anticipation, fears, and wonder of birth had culminated at the instant I saw Daniel's face for the first time. They brought him to my stomach bundled in his blanket—and there he was, clear-faced, calm, relaxed, and knowing, looking right into my eyes. It was that moment that I thought was most powerful. Meeting your future—and Daniel somehow put me at ease saying, "Everything will be just fine." He exuded confidence with understanding for others with his eyes. I felt it at his birth, and I feel it today now that he's four and a half. He is a guide, and a gentle soul. He has a deep ability to focus and concentrate, and a commitment to justness, friendship, and love. He amazes me, and engulfs me.

David had a breech birth. They whisked him away from me, and had him sleep by himself under heat lamps. He was brought to me a few hours later. When I first met this beautiful little being, I felt he needed me to guide him, to encourage and reassure him, to ease his fears, to hold him. He reached out for my contact and warm touch. David has a zest for life, detail, and affection. He has a willful commitment and attachment to the things in his world, and draws me right in, making me see its reality. He challenges me and melts me.

The boys' relationship with each other is stronger than any. They are so close to one another and they walk hand in hand through their lives. My husband and I are central to them, yet they are central to each other.

My dedication to and love for music and performing has been incorporated into the family, and hopefully into my children's ideals for seeking and pursuing a meaningful expression for themselves. It is my challenge to move smoothly between my home life as a nurturing, loving, step-to-the-side-and-let-them-grow mother, to the stage, as an expressive, self-possessed, loving performer. The contrast is astounding. I am often overwhelmed, but happily full.

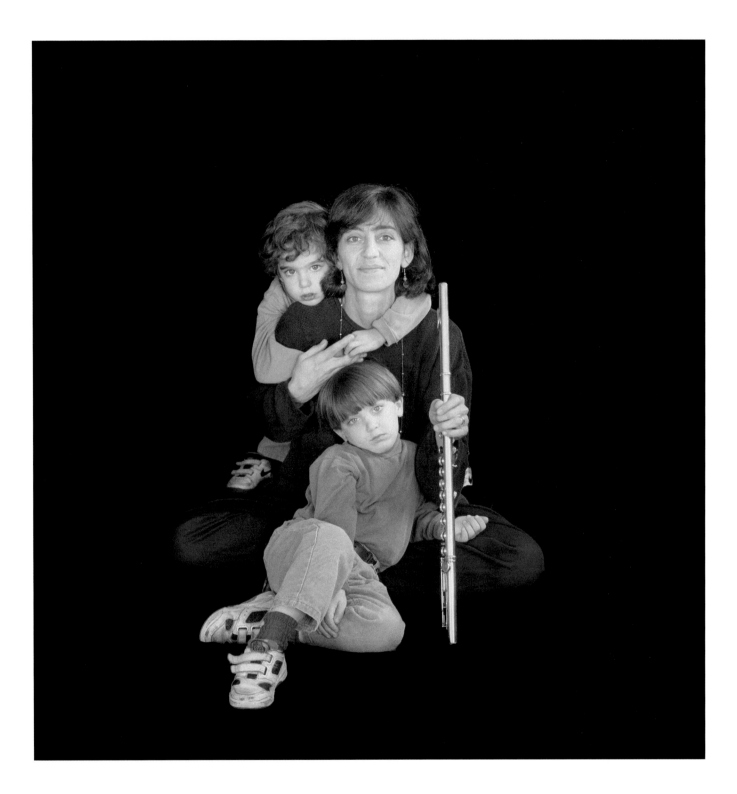

TAPESTRY DESIGNER **ELIZA SWIFT BAER** [*and*] **GABRIEL BAER**
AND HOMEMAKER

San Francisco

1994

ELIZA SWIFT BAER Gabriel Jacob Baer is a wonderful friend. He is my only son and he carries in his nature many qualities which remind me of my two brothers, and of my father, and of my husband. He is also a real surprise. He is someone I can take on long driving trips and never have a tedious moment. He is curious about everything around him. He loves to have a conversation.

Last night, as we were driving from New Mexico into Arizona on our way to California, Gabe asked, "Daddy, do stars grow?" This started a two-hour conversation on stars, light, time, matter, and the nature of the universe.

Gabe has told me he would like to be a father when he grows up because he loves to play with kids more than anything. He would also like to live in Hawaii, as long as he could still go snowboarding.

This Christmas Gabe decided that he wanted to learn French, then Italian, and speak fluently in both. We gave him a French book and he has been trying to figure out the words on his own. I'm not sure where this desire to learn these languages comes from. He says he likes the way they sound, and he wants to study them. This is surprising for a ten-year-old boy who would rather be rollerblading than reading. But I know he has the strength and the heart and the mind to do whatever he dreams of doing.

GABRIEL BAER My mother is the nicest woman in the world. She makes me good food. The best thing that she makes is salad with avocados, cucumbers, lettuce, and fennel.

She thinks that an avocado is a nut, and that Pueblo was once the capital of Colorado. We like to tease her about this. She got us the best puppy in the world. The most interesting thing we did together was drive 900 miles in one day to see this puppy when she was five weeks old. We left at five in the morning and got back at three-thirty the next morning.

She is the best. There is no word that describes her. I love her so much that there's no number that she ranks.

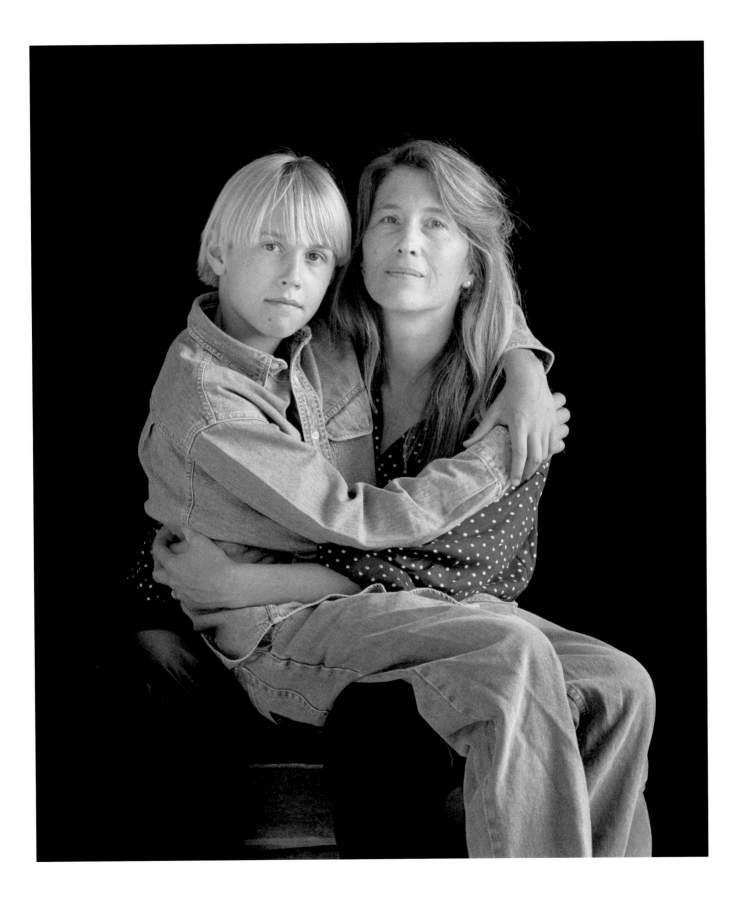

WRITER **RITA TUROW** [*and*] **SCOTT TUROW** WRITER

Chicago
1994

RITA TUROW My son received the special love that comes to the first-born and the kind of bonding a mother has for a male child.

I wanted him to learn independence; nevertheless I held his hand and guided him until he no longer needed to be led. Then I watched over him, sometimes anxious, most times with joy, and always with great interest as he made his way through life. I am happy and proud of the man he has become; an intelligent and caring human being with wonderful talent in his art and excellence in his professions.

As the years have passed, I'm aware of a reversal in our roles. Now he watches over me. It is I who come to him in search of answers, knowing if ever I need once again to hold his hand, it will always be extended to me.

His payment in kind is the joy in his own family and the unspoken knowledge that one day his children, who perhaps ask now if he loves them equally, will be there for him too.

SCOTT TUROW My mother, without doubt, was the source of my literary aspirations. When I was a child, she wanted to write. I felt her longing powerfully, the way children do, and it took root in me, well before I had any other reason to lay claim to literary ambitions—a kind psychological version of those alien visit movies, where spores are planted in unsuspecting earthlings.

My mother was able to write only fitfully. There were small children and little time. In those years, she worked principally on children's stories. I can still recall them: "The Round, Round Land of Boo," where the residents rolled, not walked. A space tale about the magical Captain Bobby. And one story about two boys who find fifty cents and eventually decide to split it. A publisher was interested, but was afraid the ending, where property was divided, was socialistic. It was, after all, the 1950s. My mother also worked on a novel about an elderly woman, a Yiddish-speaking immigrant, who wanders onto an airliner accidentally and is deposited in Los Angeles. She read as much as she finished aloud to my sister and me and we loved it. It was funny and touching. I can't account for why it wasn't completed.

When I decided as a teenager that I was serious about a literary career, my mother worried for me. She had read Irving Stone and was convinced that Michelangelo, in spite of his genius, lived in misery. Who would want that for her child? Better medicine, my father's field, than the agony of art—not to mention the penury. I ignored her. The damage, I guess, was done by then.

Coincidentally, our first books were published around the same time in 1978. Hers was called *Daddy Doesn't Live Here Anymore*, nonfiction about the children of divorce. She's still writing, here and there; mostly features about suburban life for the *Chicago Tribune*. I hear there are poems, too, though I seldom see them.

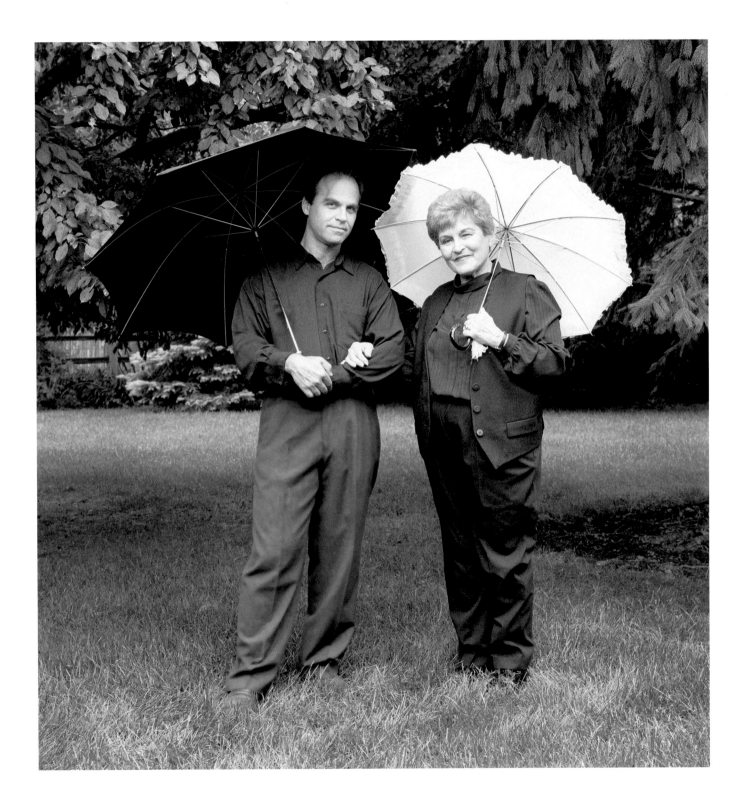

ARCHITECTURAL CONSERVATOR **ELIZABETH DELUDE-DIX** [*and*] **DERMOT DELUDE-DIX**

Jamestown, Rhode Island
1995

ELIZABETH DELUDE-DIX A child can create tremendous vitality at the core of your life and astounding activity at the edges. This small person, my son Dermot, has been defining the edges for nearly eight years. On one Friday night in 1987, it was just my husband Peter and me in our house in the East End of London. By Saturday there were three of us. Dermot was not expected—at least not for another month. Yet here he was, this very small person, impossibly beautiful and absolutely himself. [Locke's notion of *tabula rasa* is complete bunk.]

At first, the edges consisted of being told when to wake up, when to provide food, when to rest, or when to play. But these edges constantly shift. At times I am propelled to some new dimension by a curious mind: Why does Saturn have rings? Why do people do bad things? How do all the voices of all the conversations fit into the telephone wire? At about age four, during a bedtime ritual, Dermot invented a game we have played many times. "Moma, I love you as high as the sky." He gave me a nudge and advised, "Now it's your turn." "Dermot, I love you as deep as the deepest ocean," was my sleepy reply. This game has roamed through the black of the dark, the tall of the mountains, the white of the clouds, and the bottom of the world…it is a game we continue to play to this day.

But the unexpected does not always bring such delight. On 21 December 1988, Peter was on his way to a one-day business trip to New York when his plane was destroyed by a terrorist bomb over Lockerbie, Scotland. Peter was a man of great joy, and passionate about being a father. Dermot and I are forced to learn some of the harsher lessons of love and loss. A child always chooses life.

DERMOT DELUDE-DIX Mama, you know I love you from the top of space to the bottom of space. And space is infinity, so that's a lot.

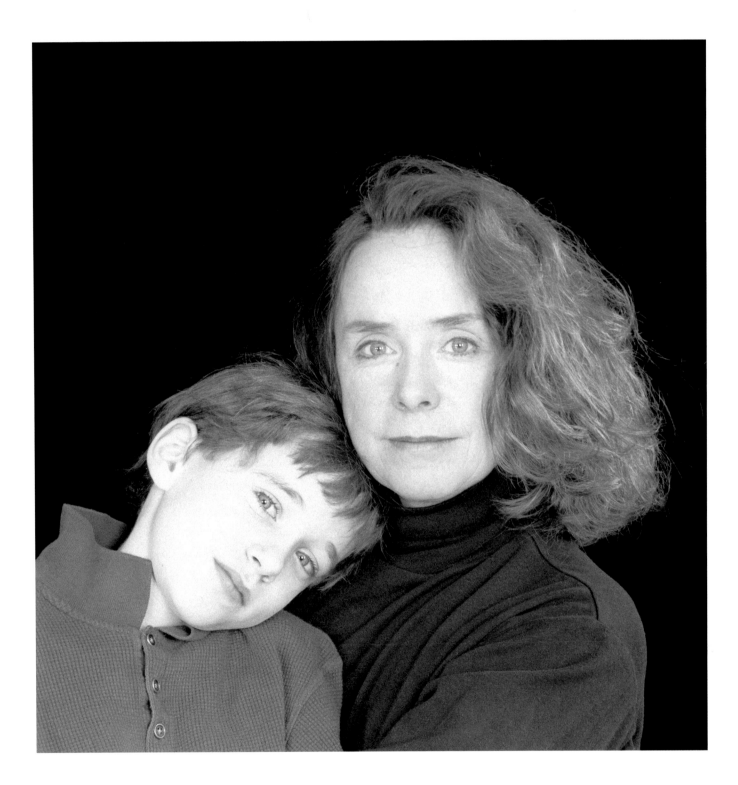

HOMEMAKER AND VOLUNTEER **NORA ATLAS** [*and*] **JAMES ATLAS** WRITER AND EDITOR
New York
1993

NORA ATLAS One should have recognized the first sign of a literary bent on Jim's part when at age three, after emerging from a heated swimming pool into extreme cold, he shouted: "I'm suffering!" as he ran for cover. An animated and funny child, Jim laughed a great deal [and still does] with his older brother.

During his early childhood, Jim's favorite activity was playing humorous games with a series of knitted rag dolls, called "Knit-Wits," which provided him and his closest friend, now also a writer, with an outlet for their fantasies. The names and dialogues they created for these characters were witty and highly imaginative and provided me with endless laughter.

At age six or seven, Jim became an avid baseball fan, and I remember an impish little boy who never went anywhere, even to bed, without his White Sox baseball cap. Although virtually ignorant of the game, I considered it a wholesome interest for a boy and contributed to his baseball card collection—which would probably be invaluable today, had it not been buried in a suburban backyard.

In his teenage years, in a period unsympathetic to counterculture views, Jim's father and I were summoned to his high school to be told that Jim and other students were publishing an underground newspaper, which was strongly disapproved of by the administration but not by me, since I felt that this was evidence of his creativity and was eager to encourage it.

Sharing with me a somewhat volatile personality, Jim, in a rebellious mood one day, left the high school bus; an act that was immediately reported to us by a fellow student, who quoted him as saying he was running away from home. My husband and I, in a panic, hurried to downtown Chicago, combing various bus stations to no avail. My desperate call to his father's office revealed that Jim had sought refuge in Brentano's bookstore. Ecstatic at finding him there, poring over Camus and Kafka rather than en route to some remote city, I rewarded him by taking him out to lunch. So much for my role as a disciplinarian.

JAMES ATLAS I never felt that my mother approved of me. For as far back as I can remember, there was always this nagging sense that I had done something wrong—what, I never knew. Maybe it was that while she was driving me to tennis tournaments or heating the Campbell's tomato soup or picking me up after my flute lesson at the North Shore Music School and taking me out for a hot fudge sundae in Winnetka, she wished, on some deep unconscious level, to be doing something else, something that would express her own inchoate and long-buried ambitions. After all, she had been a journalism student at Northwestern; she wrote articles for the student newspaper; she possessed a sensibility. Why should I be the one who got to live? We think of our mothers as only that—mothers; imagining ourselves the center of the universe, from which others radiate out—parents, children, lovers, friends. In my mother I sensed some stifled potentiality, some *anger*, as if she had given up a part of her life for mine. Maybe this was the source of my guilt.

She was a mother of a generation and a milieu that saw mothers as housewives. She never worked; her husband went off to the office every day, leaving her at home in our suburban ranch house with her two children; though I felt like an only child, as my older brother always seemed to be off somewhere. Alone in the house with my mother, I felt the mother|son romance intensify, the natural bond somehow become illicit, even in some subliminal way adulterous. A heavy burden for an eight-year-old! Was it any wonder that, while other children rode their bicycles up and down the street or played pick-up softball in someone's backyard, I lingered in my room, haunted among my baseball cards by some obscure, unnameable conviction of deficiency? To this day, I feel frightened whenever I'm in a room with her—even in my own living room, surrounded by my wife and children, a forty-five-year-old man in a suit, arriving home on a warm June night, with a briefcase full of work. Sometimes I feel that my mother alone really knows who I am—the furtive boy, the trespasser, the secret wanker in his room.

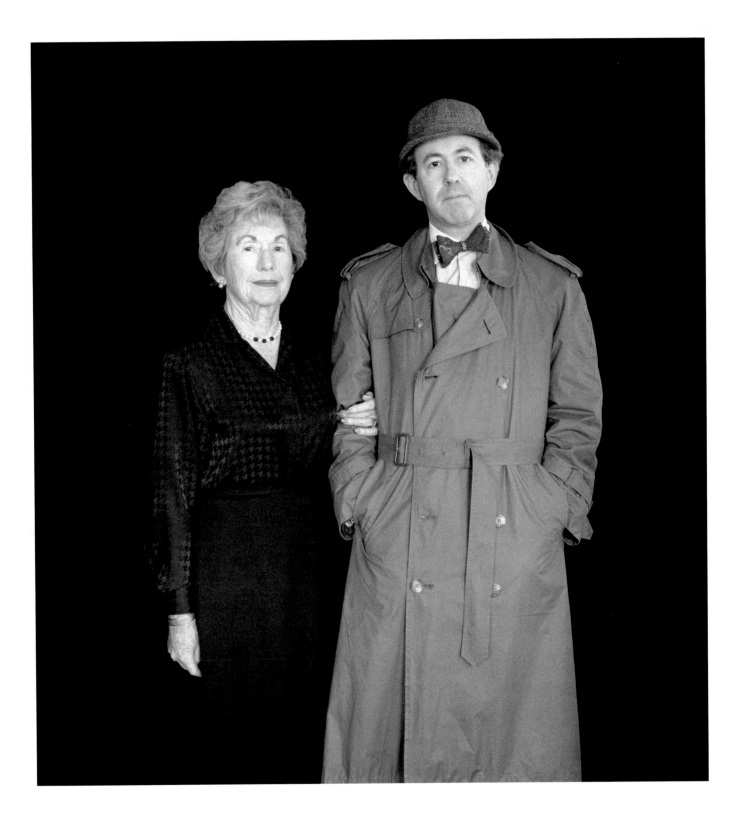

UNITED STATES RUTH BADER GINSBURG [and] JAMES GINSBURG CLASSICAL RECORD PRODUCER
SUPREME COURT JUSTICE

Washington
1993

JAMES GINSBURG As a child growing up, I always wondered why people only asked me what my *father* did for a living. I usually volunteered information about my mother anyway. Eventually, it dawned on me that having a mother as well established in her profession as her husband was unusual. Yet Mom managed to find the time to do all the things a mother was supposed to do. She was always home for dinner, in those days even sharing the cooking duties [she was eventually retired from the kitchen]. After dinner, she and I shared the cleaning chores, followed by her going over and helping me with my homework. [Help sometimes consisted of telling me to rewrite my English essay from scratch.] The main difference, I suppose, was that when other children woke up in the middle of the night to get a glass of water, they probably didn't find their mothers at the dining room table reading stacks of legal papers and sipping eight-hour-old coffee.

From her amazing example and her toughness on my schoolwork, I learned the virtue of hard work—at least when it came to working on something I cared about. But my mother is also someone who truly cherishes those rare hours she devotes to pleasure. Her favorite pursuit is the opera, which she chose to share with me at a precocious age [for which I am eternally grateful]. I quickly came to love the medium—especially the music—but I also loved seeing how moved my mother could become, never failing to weep at the end of all the great Verdi and Puccini tragedies [although my father and I suspect that were someone to write an opera about the life and times of Mickey Mouse, she would probably cry at that, too].

Perhaps the greatest part about Mom's promotion to the Supreme Court, besides seeing her rise to the pinnacle of her field, was reading and hearing all the tributes to her by so many people. Even more gratifying than comments about her professional prowess were those stories of how she helped people with a personal problem, or checked up on them when they were sick, or sent the perfect gift for their child's birthday. As with my own growing up, when she always managed to be there for me [even, as with those English essays, when I didn't want her!], I simply marvel and wonder how she finds the time.

RUTH BADER GINSBURG The joy of parenthood is to experience the development of a "lively" child into a fine human. My son James has given me that special pleasure. His passion for beautiful music led him to resist the "family business" [James's father, mother, sister, and brother-in-law are all in lawyering lines], and instead to pursue his talent for making exquisite music. Attending a musical event with James is a treat. His intense appreciation makes the performance all the more vibrant for those in his company. This photograph, I believe, captures our relationship—my pride in him, his genuine caring for me.

James made a picture for me when he was in second grade. He was told by his teacher to describe his thoughts about his mother in crayon image and in words. I have no clear memory of the image, but the words were: "My mother is to me like a summer day." The mischief and the messes became less trying as I held that thought in mind. How fortunate I am that my son, now a man, is today my very dear and close friend.

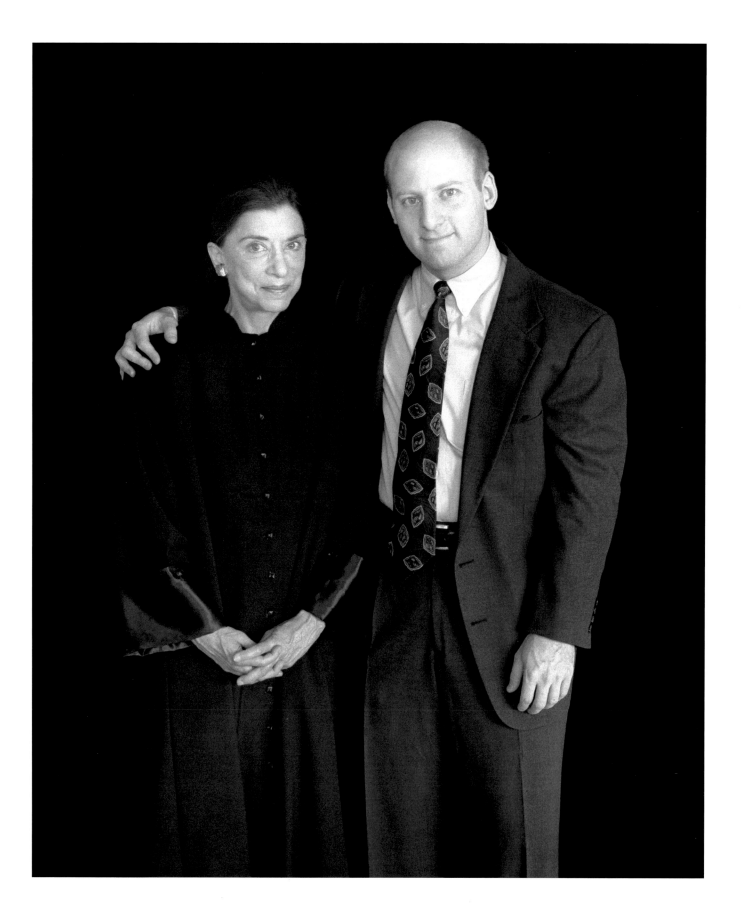

MUSEUM TRUSTEE **EMILY OTIS BARNES** [*and*] **NATHANIEL OTIS OWINGS** ART DEALER
Santa Fe
1994

EMILY OTIS BARNES My son Nathaniel—who is called Nat—looked me straight in the eye the day he was born and smiled. He is a Christmas Eve child, and somehow all that lovely season implies is inherent in his soul. There is the warmth, compassion, strength in trial and stress, and the constant search for the spiritual essence that is to be found in life and people. Also there is in him a prodigious and often irreverent humor that I like to believe he receives from his mother.

Growing up in northern New Mexico, [we came here when he was two] has I'm sure influenced greatly Nat's intense dedication and love for this land and its people. This is manifest now in all that he does and in the way he achieves it.

There are many anecdotes that come to mind from his growing-up years, such as the summer in his middle teens when he worked in a camp in California and one day called to say that he had shot his first elk, and would I like to have its liver? I declined. Now he likes to be in the wild, without killing.

Nat has gained and will always benefit from his deep absorption in history and in art, and the people who have come before. His first career involved teaching and counseling in the field of communicative disorders—in great part with children. Now he is here in his art gallery. I feel that these two elements that have dominated his adult life must be for him a most unusual and abundant endowment from which he cannot help but be enriched as he proceeds through life.

Nat and I are indeed mother and son, and how blessed I have always felt that this is so. Added to this are the love and the blessings that grow from an abiding trust and friendship that exists between us, now and forever.

NATHANIEL OTIS OWINGS There was a world, into which I was born, where parents and children very soon went their separate ways. Not by choice necessarily, but because that was the way it was done: the task of raising children. Into the place of parents came others who looked after the children, tended to their needs and tried to ensure that the children would want for nothing. But want they did, despite the care. It was not a want for food or warmth in winter, but a want for love and a want for a safe place when the heart is lost or empty or afraid or even joyful.

Once I heard my mother say that at a pueblo in New Mexico she saw written: "A heart must be before a thing can exist." Early, I learned that simply because a heart beats, it does not necessarily "be." That required that one *become,* slowly over time with nurturing and love and all that implies.

My mother tried with all her resources to nurture and love. At times she succeeded, but the odds against her were formidable. They blew like a harsh wind across the lakes of her youth. Those odds against her sapped strength from what was required of her as a child and from the man she married. And still she fought back as best she knew how. And here and there she broke through and was a mother.

At age ten I awoke from the tonsil trauma and she was there. She sat in a small white chair reading beside my bed. When I awoke, it was she I saw first and for that moment I felt safe. Again, all too early in prep school at age twelve, I became convinced one night that she had died. Her voice on the phone reassured me and the terror passed.

Never can I at last judge my mother for what she did or did not do for me as a child. The deck was stacked a certain way when I was born upon this earth. I know that on that Christmas Eve night, now long ago, I was loved by my mother. I know that today I am loved by her and I return that love for the gift of life she gave to me. As for the years and miles between, perhaps all of that is necessary for the heart to be.

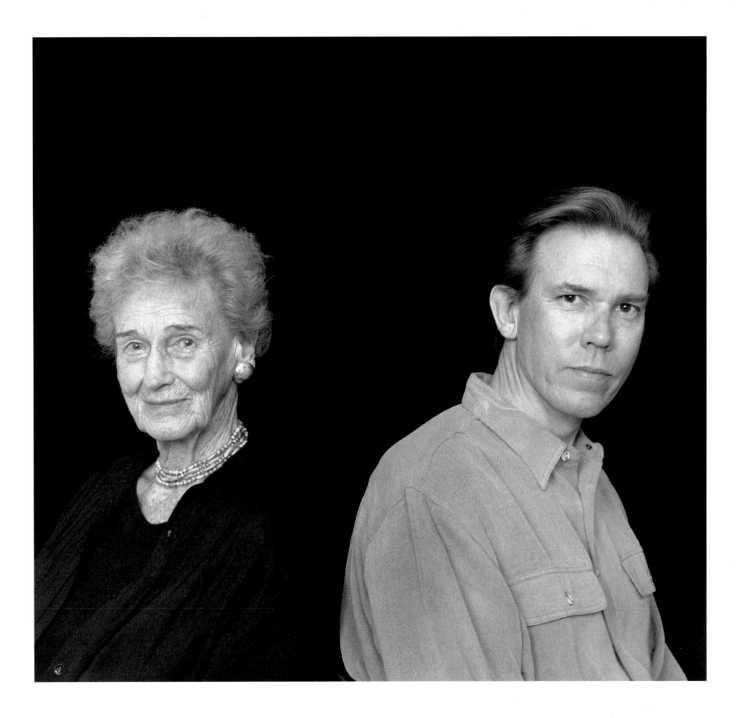

ARTIST AND WRITER **ODETTE JOYEUX** [*and*] **CLAUDE BRASSEUR** ACTOR

Paris
1993

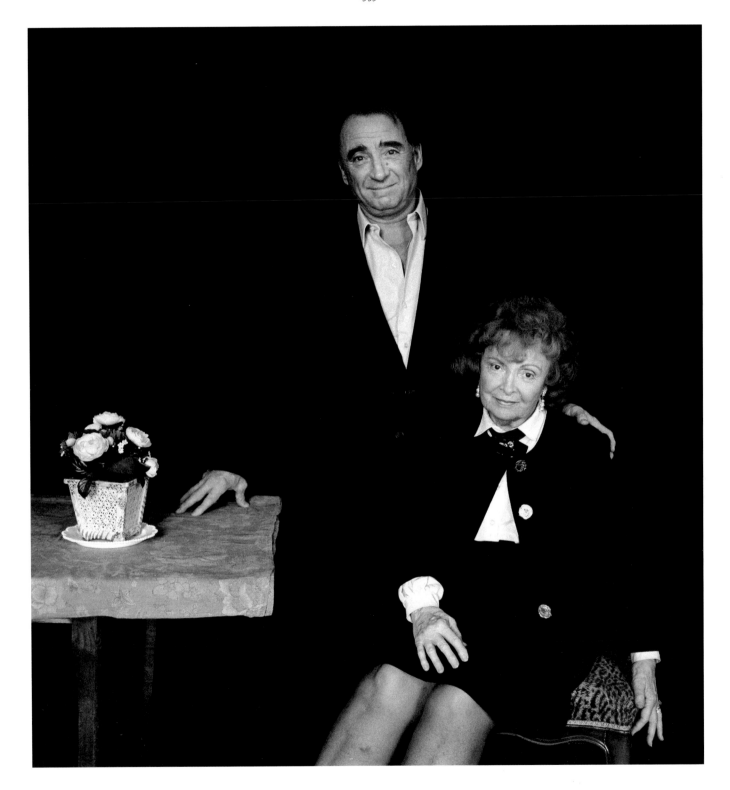

ARTIST ROXANNE SWENTZELL [and] PORTER PAUL YORK SWENTZELL

Fairview, New Mexico
1994

ROXANNE SWENTZELL I had him illegitimately. I had him all the way. He was mine. There was no other person. When I think of Porter, I think of the time when I had him. It was a really hard time and he gave meaning to my life. As a person, he's one of the most warm-hearted beings I know. Sometimes I think that he came into my world to tell me that someone loved me.

Porter is someone who has over and over again gotten me to see very different sides to things. I raised him trying to *not* encourage images of boys and girls. We had no television. We ended up home-schooling him and he wasn't given "boy" things, as I had seen other little boys being given. I wanted to see if it would make a difference being raised the same as his sister. One of the shocking moments to me was when he was about four years old and his sister was three. We had gone for a picnic up the canyon in an arroyo. Porter and his sister, Rosie, ran off to play. The game they decided to play, which Porter came up with was, "War." He would attack a village with Rosie at his side. I watched with amazement as Porter pretended to shoot and fight with imaginary people. Rosie ran behind him, busying herself with something imaginary on the ground. Porter finally stopped and asked what she was doing. She told him that she was taking care of the babies. Porter was confused but continued his rampage on the village and Rosie continued caring for the babies strewn about on the ground. Of course I felt like I had failed. He had become a "boy" anyway. I guess because I loved him dearly, I had to look closer to see if there was or could be anything good behind this "boyish" attitude of his. He certainly has and still is showing me that what lies behind the "War" is a kind of passion. Porter has much passion—that's where we are the same.

PORTER PAUL YORK SWENTZELL I live in Santa Clara Pueblo Indian Reservation with my stepdad Joel, my Mama, and my sister Rosie. I live in a solar adobe house my Mama built. We have two sheep, eight turkeys, seven chickens, and about ten quail. We used to have a pig but we butchered it, and that was sad because it was like a pet. We also have one beehive; we used to have three, but two died out. We grow some of our food, and we grind most of our flour on a bicycle hooked up to a grinder. Also, me and Rosie home school, and that is a lot nicer than going to school. We learn a lot when we butcher a chicken or turkey, and right now we are making hams and bacon out of our pig. We are thinking of turning off our electricity and that will be interesting. I like my Mama a lot even though she can be scary when she gets mad.

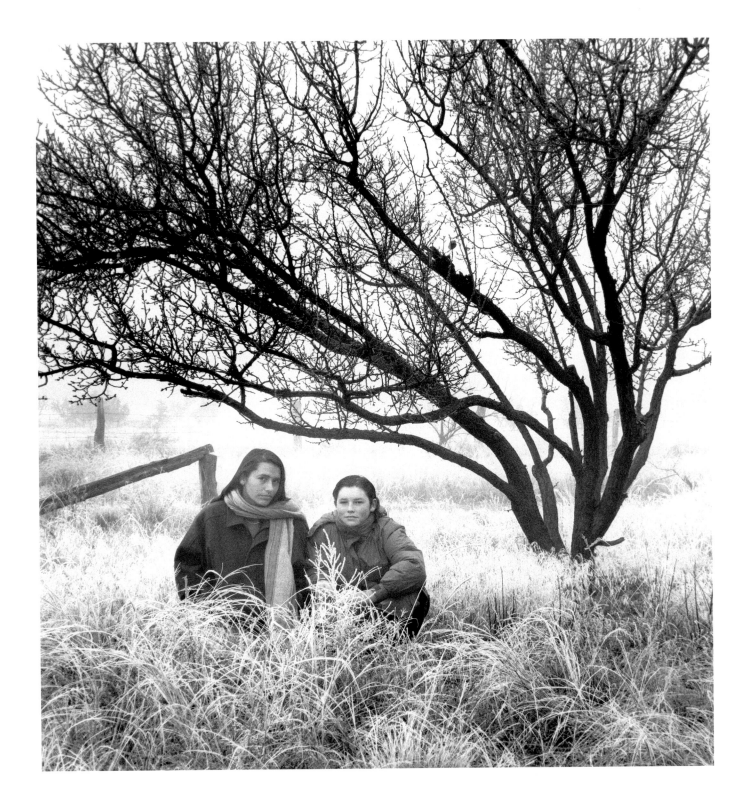

NOVELIST **ANNE LAMOTT** [*and*] **SAM LAMOTT**

San Rafael, California
1994

ANNE LAMOTT I felt wasted and overwhelmed the day this picture was taken, because Sam had been coughing in his sleep a lot the night before. So I thought, "Well, at least let's make the kid look great." I dressed Sam in his finest clothes–an Arrow dress shirt from a secondhand store, perfectly worn blue jeans, and cowboy boots.

While the photographer was setting up the black velvet backdrop in our kitchen, Sam [who, like native Americans, is very suspicious of having his picture taken] went off to his room for a few minutes. When he returned, he was wearing these terrible red, black, and yellow plaid pants that someone bought him at a street fair; a black Mickey Mouse T-shirt sprinkled with glitter; and canvas sneakers from K-Mart, in black, red, green, and blue, and on the wrong feet. He looked like Jerry Lewis, or someone who might sit on the streets of San Francisco collecting money in a Styrofoam coffee cup, with a cat on a leash beside him. And once again, I shook my head in wonder at my son. He will not let me make him into who I sometimes think he should be.

His will is very strong, and his heart open and tender. There are times when I want him to act like "a big boy" because that would be convenient for me; our life would run more efficiently if he would act like a little man, instead of a small boy. Instead he sometimes still weeps and clings when I have to go somewhere without him. I worry that I have wrecked him. But the other day he was having a hard time letting me leave, and I started getting impatient and even chagrined that he was being such a baby. Then he looked at me solemnly and said, "Let me keep kissing you until I can stop crying," and I was able to let him do this, and then he did say good-bye, bravely, in the manliest possible way, and I said to myself, "Ain't no one wrecked here on this bus."

SAM LAMOTT She has curly hair, like squiggles. Some is blonde, some is dark. Her eyes are green and red and white. They are a little big. I like that Jesus gave me to her. If I had another mother, I would hate it. I would just love that other mother a little. I like Annie's nose because she has nostrils. I like to swim with Annie in the deep end like fish because I feel safe.

KENDO MARTIAL ARTIST **RITSUKO SUZUKI** [*and*] **YUTA AND DAISUKE SUZUKI** KENDO MARTIAL ARTISTS

New York
1995

RITSUKO SUZUKI My children are a very good combination. My ten-year-old son Daisuke helps me a lot and treats me nicely. Even if I'm tired, he comes to cheer me up and make me laugh. My fifteen-year-old, Yuta, takes the place of my husband every time he's not there. He helps me carry the groceries. These days, he is able to talk to me as if he's my friend.

YUTA SUZUKI From the day I was born, I felt very satisfied and happy that I had a fine mother. She would help me on things I was stuck on. If I ask her a question, she will give me the most possible answers she can think of. I am happy and pleased for having a nice and kind mother. There is no other mom in this world that can take her place.

DAISUKE SUZUKI My mom is really nice, funny, and really different from other moms. My mother cooks nice foods but sometimes her cooking is a little bad. I feel it's unfair sometimes because she doesn't go to school and she's taller than me.

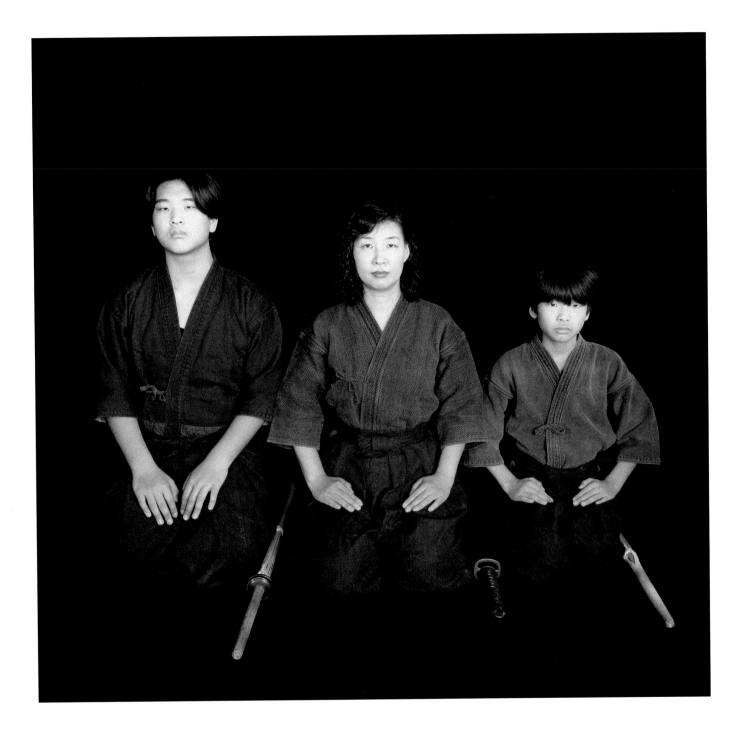

RESTAURANT OWNER **LEAH ADLER** [*and*] **STEVEN SPIELBERG** FILMMAKER

Los Angeles
1994

STEVEN SPIELBERG When I was a little boy, my Mom had a 45-rpm record. It was by a very, very talented harmonicist who would speak music through his instrument: "I want my Mama. I love my Mama." It wasn't his voice. It was through his harmonica. I played it over and over again. It was the musical equivalent of my love for my Mom.

LEAH ADLER My Momma used to watch me dealing with my little creative devil and through the years repeatedly said, "Mark my words, dolly—the world will hear of this boy." This was Momma's mantra.

Little did I know that this six-pound, ten-ounce Steve, this tiny blonde child that came from me, would become *the* Steven Spielberg. Looking back, there were signs.

Steven was not what you'd call a good student. We had tutors schlep him through courses. Of course, there was lots of absenteeism. If the kids didn't want to go to school, it was okay by me. Steven would do the thermometer on the lightbulb trick [like in *E.T.*]…I played along. Then, an hour later, Steven would perk up and say, "Let's go out in the desert and make films." Projects were always very exciting for us. My kids were very soon my size and we were like a gang, all of us together, piled into our Army jeep…camping trips, movie-making…a seemingly constant whirl of activity.

I couldn't say no to him. Steven could really push the buttons. We had some great fights…always knowing we had a wonderful connection. I just held on during the wild roller-coaster ride that was Steven. We've always been very, very close. I learned that you don't have to always be an adult with children. I understood where all my kids were coming from. I still do. Arnold, Steven's father, was the one adult in the family.

I feel as if my life is a dream. I can't believe it's real, that Steven's reached the heights he's risen to and become the kind of person he is. I can't take any credit for it. Whatever I did was not premeditated child-rearing…I'm too much of a kid myself for that. It's fun being his mom. I always know who I am, though. I'm Leah Posner, from a poor family. Whoever you are when you are seven years old is where you stay.

I look at all the special gifts Steven has given to the world…but his biggest gift to me is the constant love I get from him. I'm *so* proud! Momma and Dadda would be so full of love and pride, too. You were right, Momma!

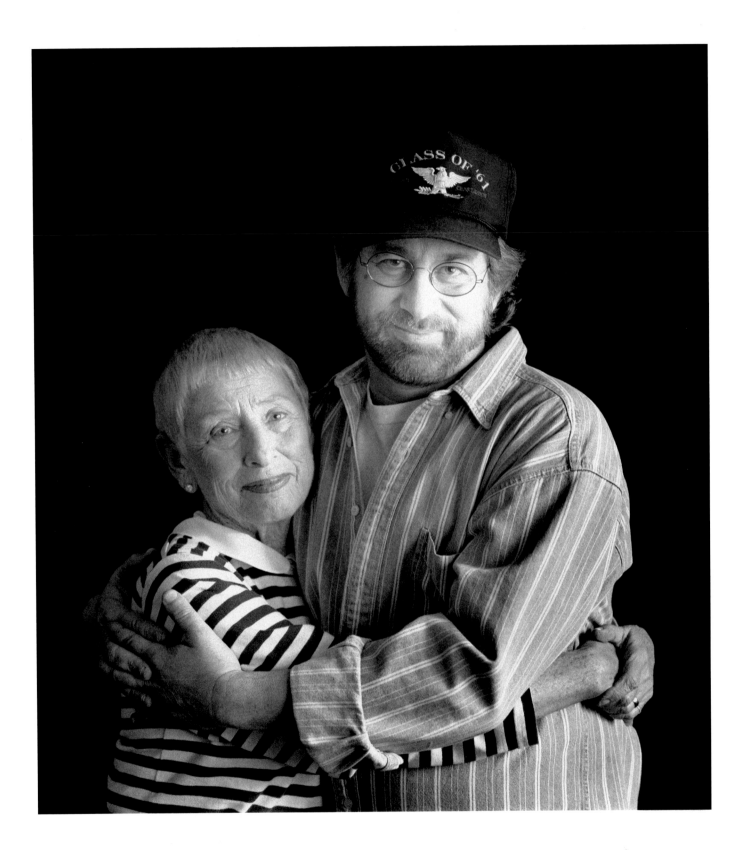

HOMEMAKER SUSAN NAKAMURA [*and*] YUGO NAKAMURA

New York
1993

SUSAN NAKAMURA Yugo may always be ten years old to me. Ten is my favorite age; helpful, loving, and always concerned about my feelings. If I'm upset, he is ready to try if he can to smooth the way and restore my good humor. Even when Yugo does something wrong, I can't stay angry at him for long. I melt at his look.

Yugo is a constant source of joy—a budding comedian. "Mom," he queried, "Why do boys dress and act funny when they're older?" I answered, "Older boys try to dress and act in a way that will make them attractive to girls. Do you like girls yet?" "No," he said with a glint in his eye, "except you." I will always remember Yugo at ten.

YUGO NAKAMURA In serious stuff, Mom's always positive. Sometimes she makes fun jokes. Even though she is really busy with three kids and doesn't have a lot of time to spend with me, it's really nice to be with her because it feels like vacation time—except when she shops and goes crazy.

I like her comments because I think she's wise. For example, in school all the children have air guns and I don't have one even though I wanted one. But Mom says it is dangerous because it can hurt your eyes.

Japanese people are more embarrassed by little things than Americans are. If you're not embarrassed, you feel clearer. She teaches me not to be embarrassed, so I feel freer.

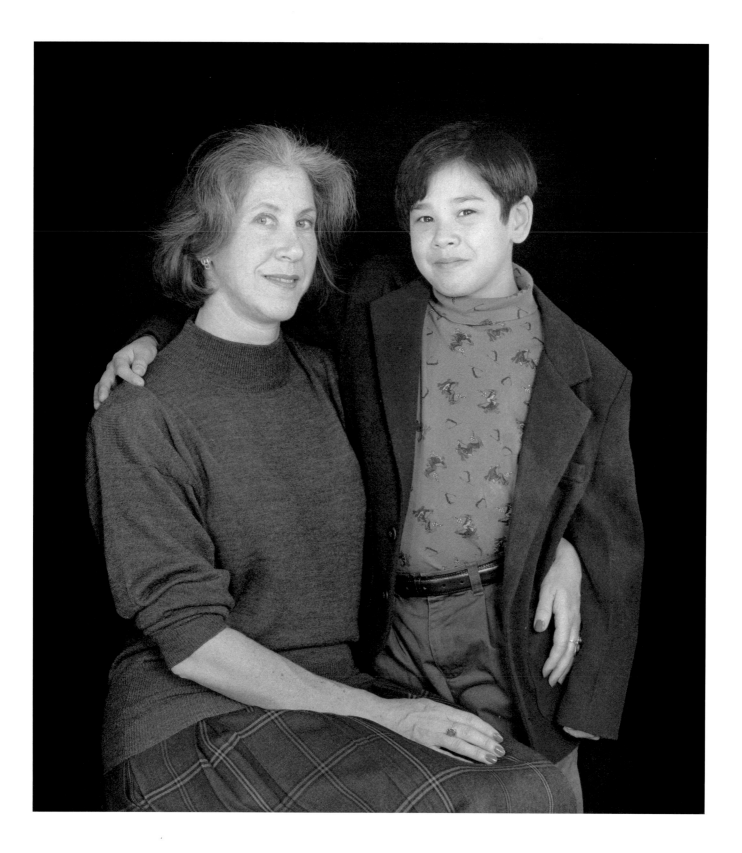

ACCOUNTANT **PAULA HERSHKOWITZ** [*and*] **JESSE HERSHKOWITZ** STUDENT
London
1994

PAULA HERSHKOWITZ As I write this, my son Jesse is on a 1500-mile charity cycle ride across Europe, trying to raise money for Bosnian children. The journey he is taking seems to symbolize the young man he is becoming. I feel proud that he is bright, independent, and confident, but also caring of those who are less fortunate than he is.

Mariana's photograph reveals this strength which enables him to go out and make his way in the world, but it also shows the need he still has to be in touch with his mother [and his mother's need to be in touch with him, of course]. Perhaps these aspects of his character represent the two differing sides of his background. His father is a Bronx-born Jew, now living in England, whose grandparents emigrated from the Ukraine and Hungary, while his mother is a stolid Anglo-Saxon, still living in the same English country where her ancestors lived.

I loved caring for Jesse when he was a child; reading to him, teaching him to read, singing interminable nursery rhymes to put him to sleep, wandering the lanes of the Sussex countryside with him. He was a happy child, gentle and good-natured, never interested in games of aggression and [almost] unfailingly tolerant of a lively and noisy younger sister.

Although Jesse may seem to be a suitable candidate for canonization, there is another side to him. He has a stubborn streak and does not take advice gladly, and can be appallingly arrogant, but perhaps these traits have been nurtured by years in the English public school system. He tends to regard his parents as mental and physical incompetents, but he does take pity on his aging mother enough to partner her in an occasional game of tennis, and even seems to enjoy it.

JESSE HERSHKOWITZ I'd like to think that I have a close relationship with my mother—so long as I'm on the right side of her temper. She can be unpredictable, yet more importantly she's reliable, and has supported me in everything I've done [though I haven't actually mentioned to her my planned expedition across Antarctica on a pogo stick].

I have very distinct memories of her when I was young: driving my toy cars over her stomach when she was pregnant with my sister, walking to the local village shop with her to buy an ice cream, her painting my portrait while I was watching children's television. She's a very talented artist, and I admire her greatly for that.

We still get along. We share a very similar taste in comedy; Monty Python is our particular favorite. Her tolerance was most recently shown when she took me out for driving lessons while I was still learning. Next year I'll be off to university, and so won't see her for months at a time, much longer than at Westminster. I suppose I'll miss her then.

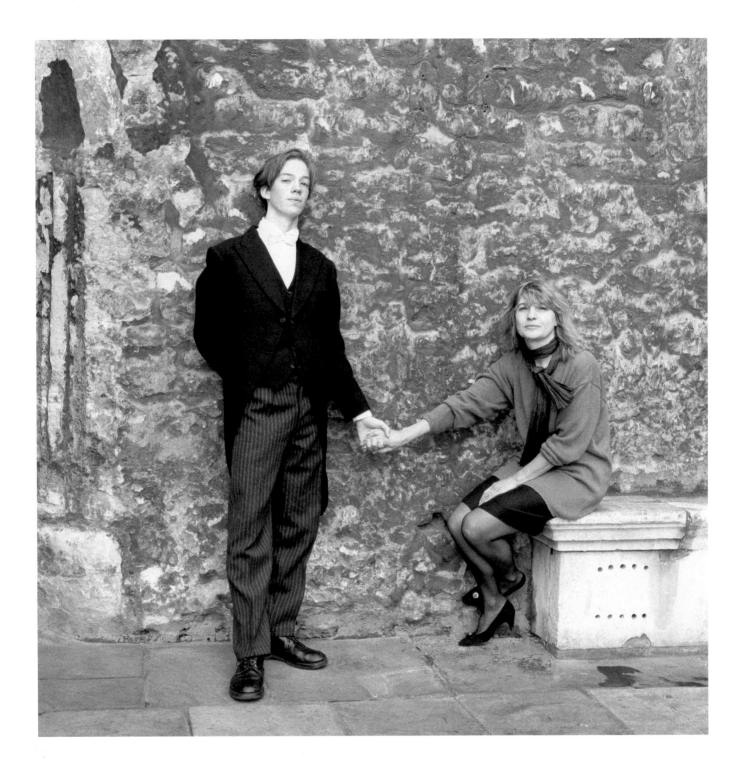

CIVIC LEADER **RUTH M. LEFFALL** [*and*] **L^ASALLE D. LEFFALL III** ATTORNEY
New York
1994

RUTH M. LEFFALL I am honest enough to admit that as parents of an only child, a son, my husband and I cannot pretend to be objective. Donney, as he is known, has been such a gift to us. As a child he was precocious, full of joy and fun and although the center of much attention, oddly enough, not spoiled. He has grown into a fine young man with sound moral values, a keen sense of self, but also with an acute sensitivity to the needs and desires of others.

Donney is smart with a penetrating intellect, a great sense of humor, and in his favorite sport, tennis, a punishing forehand. We are a close-knit family who continue to share in one another's lives. Donney shares his father's name and his love of history, literature, and foreign languages. Although he decided at an early age to become a lawyer, he had and continues to have an interest and appreciation for his father's profession: surgery. Donney's unwavering passion for the less fortunate is perhaps gotten from me.

What a joy to have Donney as a son! He has enriched my life.

LASALLE D. LEFFALL III As a child, I took for granted how great my mother was. I assumed that everybody's mother was like mine. It was only as I became older that I began to appreciate how fortunate I have been.

A person could have no greater supporter. But, equally important, my mother tells me not only what I want to hear but also what I need to hear. I view this as a sign of love.

My mother, along with my father, has instilled in me some basic values, including integrity and courtesy. In addition, she stressed respect for others. Whenever times have been difficult, these values have served as my moral compass by which I could guide my actions. My mother did not just talk about values; her work for civic and charitable organizations showed me that making a contribution to others is a vital part of life and has its own rewards.

What has made our relationship even more special is that we have become good friends. She has a great sense of humor, and we enjoy sharing a good laugh.

If all I have said has not left an indelible impression about my feelings towards my mother, let me simply say this: She is the best.

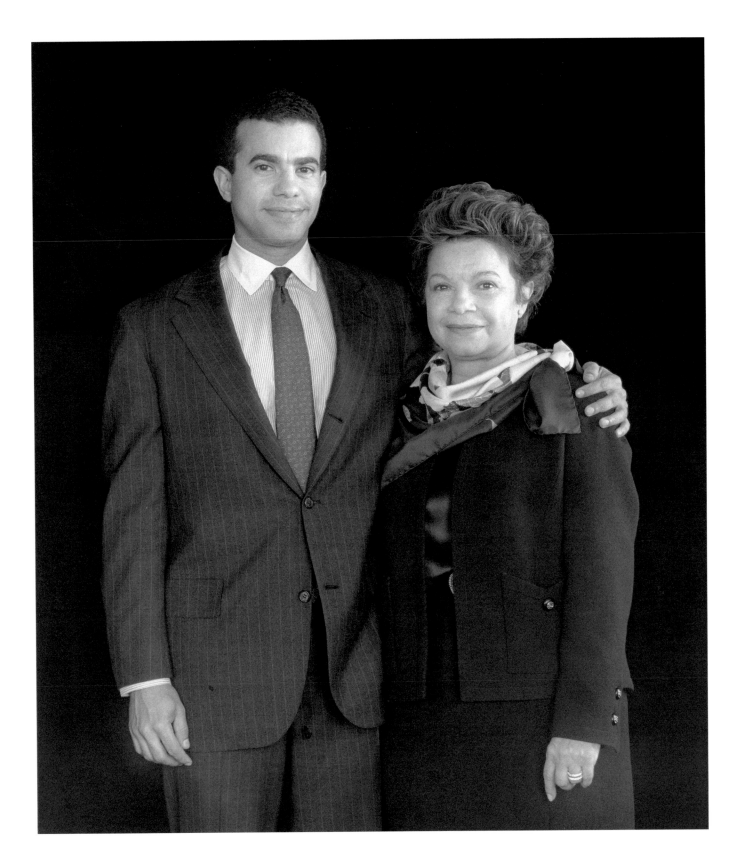

WINDOW WASHER **BEVERLY BROOKS** [*and*] **BEN FALLER** WINDOW WASHER
Indianapolis, Indiana
1994

BEVERLY BROOKS When I met Ben it was hard to believe he was for real. He was so gentle, honest, and caring. My husband was tender-hearted and when we heard Ben's life story, we all three cried. He had never known his real family and grew up with foster families till he was able to support himself.

My life was to change from that first meeting. Ben was a professional window washer. He was the best one in the whole city. He has proved that in the last twenty years. My husband backed us and we went into business. In one year we had two commercial accounts and a route that supported us. There are few women in the business but the two of us made a great team. People trusted us and we still have all the accounts we started with. That is unheard of with so many people bidding lower.

We asked Ben to call us Ma and Pop. My family accepted him without any questions. They include him as family. Ben has adopted many needy people and we wash a lot of windows for people who can't afford the service. We like that work best when we see their pleasure. Ben gets lots of hugs and kisses from the ladies; young and old, they all love him. Ben was married and had three girls, but his wife threw him out. He married again in search for someone to care and then she left him for a man with more money.

After my husband died, Ben took me into his home. My mother had a stroke and he helped me care for her till she died. I could go on forever but I think you can tell how proud I am he calls me Ma.

BEN FALLER Let me tell you about a great lady—Mom to me. I am fifty-eight years old and Mom has known me for twenty-two years. To me, she is my friend, my good buddy, my constant companion, my partner in our window cleaning business and we work together every day. Since Pop died several years ago, we share the same home, so Mom and I are together many hours every day. We never have a cross word—ever—and best of all I love my mom.

You see, her and Pop took me in about twenty-five years ago. At that time I was married and had three daughters at home. As they got to know me they said we will be Mom and Pop. Since I grew up without any parents, I was overwhelmed, and let me say they have always been there, no matter if times was good, bad, or awful and it seems in my life there has been plenty of all the above.

I never knew of a mother or father. As I grew up I was somehow put in the trust of older folks to do their labors for them, as almost all of them needed a young body to do their daily chores. I recall most all of them felt they was doing good things for me, and they was, as a helping hand for them and myself. They never asked where I come from or where I was going. But I received many values in my young life that helped me survive my own trials.

If some people say they turned out the way they are because of their past, what happened to me? In closing I must say this—boy, I'm so glad I found Mom.

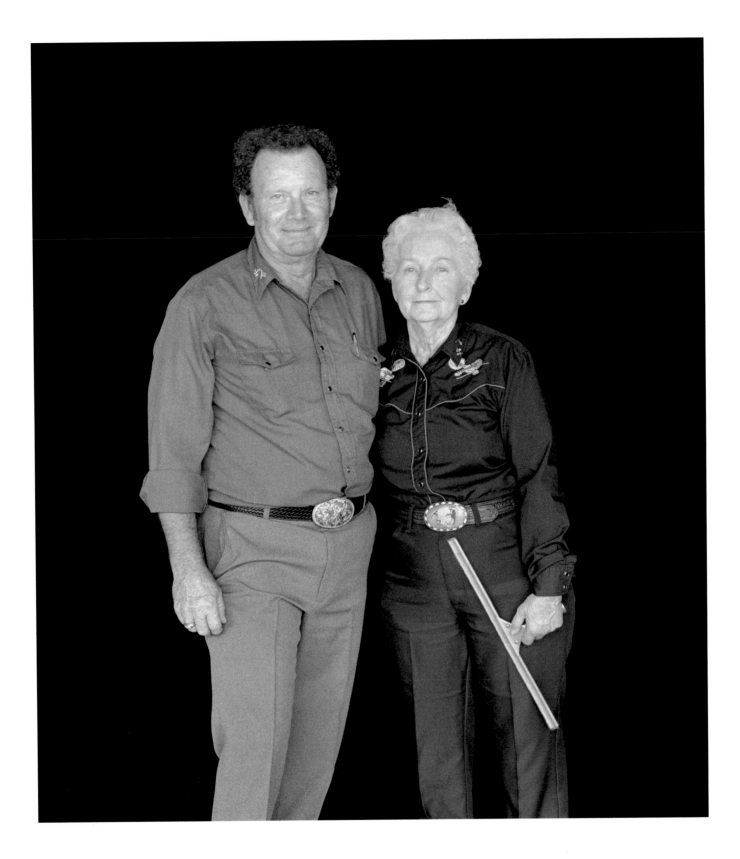

HOUSEKEEPER **LESLIE CROWDER** [*and*] **AVTAR CROWDER**

Santa Fe
1993

LESLIE CROWDER I wanted to have at least one child before I was thirty. This was not a decision, but rather an instinct. It didn't make practical sense—no marriage, no career, no money, no home—just luck.

Avtar's birth was natural childbirth at home and his name was given by a yogi who based it on the birth date and time. Now, Avtar is sweet, smart, and silly. I hope he keeps his unique, individual character throughout his entire life.

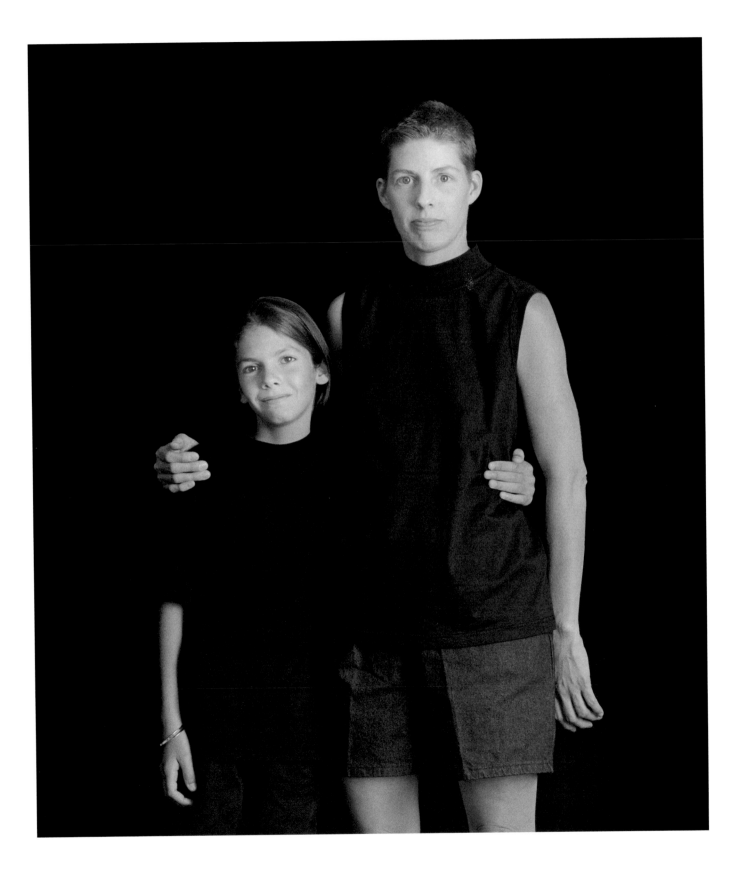

ATTORNEY **MARIAN WRIGHT EDELMAN** [*and*] **JOSHUA** TEACHER **AND EZRA EDELMAN** STUDENT
Washington
1993

JOSHUA EDELMAN When I reflect on my childhood, I remember how I always wished that I had a normal mother. My perception was that my mom was always travelling around and speaking to strange people; all I knew is that I didn't get to see her as much as I liked. She was also always strict with me. Not in an authoritarian way, but in a gentle, moralistic way. But I wanted a mom who would allow me to hang out late, go to parties, and do those things that my friends' parents always seemed to allow them to do.

In retrospect, I think that I lived through my childhood and adolescence with few scars from my mom's talks and rules. In fact, I feel that her words of wisdom, attempts to come to my games and school functions, her efforts to have us eat meals as a family, her genuine friendliness toward whomever I would bring home, and the time she set aside so that we could spend quality moments together have made me a much better person. Having grown up in a media culture that propagates mixed messages about what is important, I realize how lucky I am to have had a moral exemplar to inculcate in me the ability to distinguish between right and wrong, and the exigency to give back to those who often need the most guidance—children. I try every day to give the most of myself to the kids with whom I work. However tough it gets, I know that I always have a role model to remind me that it is possible to practice what you preach on a daily basis in your professional and personal life. I am proud to be my mother's son.

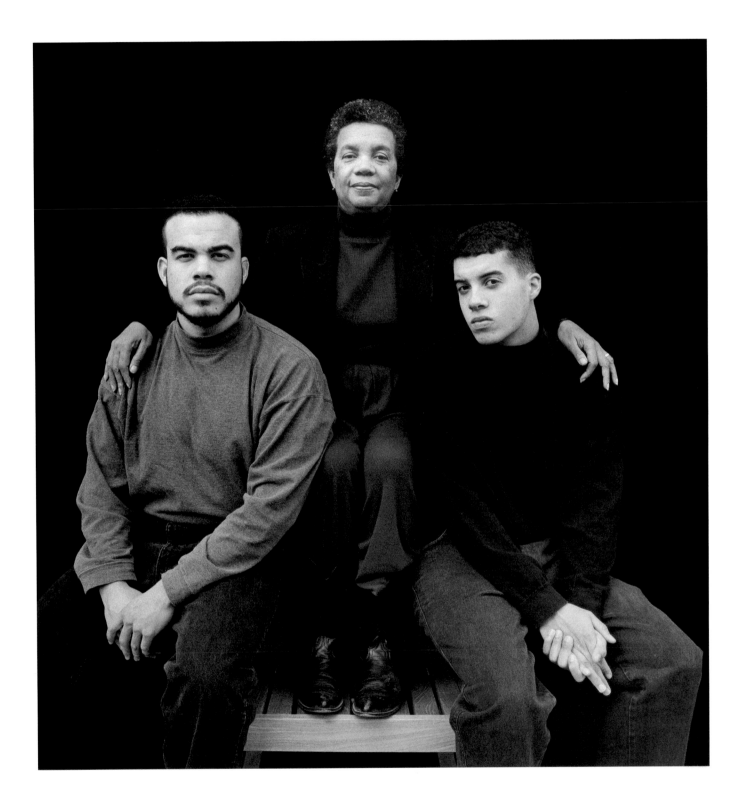

POLITICAL ACTIVIST SUE PASTERNAK [and] URI PASTERNAK

Silver Spring, Maryland
1994

SUE PASTERNAK His name is Uri, which means "my light." I call him "my little forty-year-old soul." My son was three weeks overdue. He liked it in there so much that after eighteen hours of labor they had to go in and get him; I was awake for the cesarean. They lifted him out and showed me his beautiful face.

He had huge focused eyes…he stared down at me with an incredible intensity. I felt an overwhelming passion that I think will never be re-created—I burst into tears. I knew this creature. I understood every facial nuance. An immediate bond was formed.

He was an exceptionally bright baby; very verbal, logical, loved abstract cyclical concepts like time, evaporation, math. That all continues to this day. He enjoys school and takes it very seriously. He doesn't always choose the obvious or easy paths to find answers to questions. He thinks of more complicated ways to get the answer.

Uri is a loving son. We can talk about anything. He has a sweetness of nature, a strong sense of right and wrong and what is fair. He's learning life is not always fair and my heart aches for him sometimes.

I saw this picture of us together. I saw my wise little worrier, my old-young son. I saw his eyes and I burst into tears.

URI PASTERNAK I liked the way she tucked me in at night—tickling my back, playing the "limp" game, singing, telling great stories. My favorite song was "Try not to get worried, try not to turn on to problems that upset you. Oh, don't you know, everything's alright, yes everything's fine…Close your eyes, close your eyes and relax, think of nothing tonight."

I can't turn off my brain. It's hard. Now, I need to read or watch TV until I can fall asleep. I miss my old bedtime routine. Now my mom knows I'm too mature…yeah, right, that's a laugh. Once in a while she does come in and tuck me in, but most of the time I'm on my own.

Mom is very funny and not too strict. It's easy to talk my way out of punishments. I just look at her and say, "I'm sorry," and she forgives me—end of punishment. Sometimes.

My mom helps me be creative. I don't feel very creative but I'm great at math. I also love to read. We get along really well. I make her laugh and she makes me laugh.

Sometimes she's very mean and rotten when she won't let me do what I want. But I know she does it for my benefit and not because she hates me. I know she always loves me no matter what.

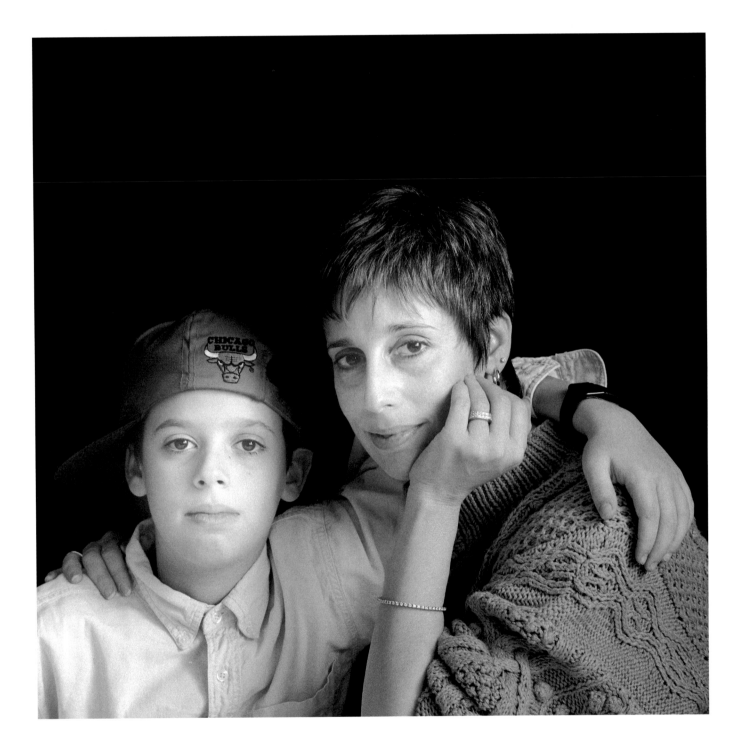

LIST OF PORTRAITS

112 ADLER, LEAH, *and* STEVEN SPIELBERG

58 ADLER, NANCY *and* ROMAN

6 ALLENDE, ISABEL, *and* NICOLÁS FRIAS

98 ATLAS, NORA *and* JAMES

92 BAER, ELIZA SWIFT *and* GABRIEL

102 BARNES, EMILY OTIS, *and* NATHANIEL OTIS OWINGS

44 BARONE, FRANCO, DOROTHEA WILKINSON, *and* JOHN SANTOS

78 BIRD, SARAH, *and* GABRIEL BIRD-JONES

78 BIRD-JONES, GABRIEL, *and* SARAH BIRD

24 BRANDT, FRISH, *and* AUGUST FISCHER

105 BRASSEUR, CLAUDE, *and* ODETTE JOYEUX

120 BROOKS, BEVERLY, *and* BEN FALLER

66 CLARK, MARY HIGGINS, DAVID, *and* WARREN

20 CHURCHILL, WINSTON S., *and* PAMELA HARRIMAN

33 CLIBURN, RILDIA BEE O'BRYAN *and* VAN

76 CLINGER, RUSH, *and* JUDITH KELLER

50 CLINTON, BILL, *and* VIRGINIA CLINTON KELLEY

74 COOK, ELAINE, JIMMY, *and* FREDDY

72 CROSS, ALEXANDRA, *and* T. PETER KRAUS

86 CROSS, DORIS *and* GUY

122 CROWDER, LESLIE *and* AVTAR

96 DELUDE-DIX, ELIZABETH *and* DERMOT

70 DIAZ, ROSA *and* GERARDO

62 DIE PRAAM, MARIS, *and* SHAMANEE KEMPADOO

124 EDELMAN, MARIAN WRIGHT, JOSHUA, *and* EZRA

14 EDELSTEIN, PAULINE *and* BURTON

120 FALLER, BEN, *and* BEVERLY BROOKS

24 FISCHER, AUGUST, *and* FRISH BRANDT

64 FOLTZ, GENEVIEVE *and* ROBERT

6 FRIAS, NICOLÁS, *and* ISABEL ALLENDE

82 FRIENDLY, JEAN, NICHOLAS, ALFRED JR., *and* JONATHAN

100 GINSBURG, RUTH BADER *and* JAMES

61 GRAHAM, KATHARINE *and* DONALD E.

20 HARRIMAN, PAMELA, *and* WINSTON S. CHURCHILL

116 HERSHKOWITZ, PAULA *and* JESSE

105 JOYEUX, ODETTE, *and* CLAUDE BRASSEUR

76 KELLER, JUDITH, *and* RUSH CLINGER

50 KELLEY, VIRGINIA CLINTON, *and* BILL CLINTON

62 KEMPADOO, SHAMANEE, *and* MARIS DIE PRAAM

11 KINCAID, JAMAICA, *and* HAROLD SHAWN

22 KISSINGER, PAULA *and* HENRY A.

1 KRAUS, HANNI *and* HANS PETER JR.

72 KRAUS, T. PETER, *and* ALEXANDRA CROSS

2 KUONI, MARTINA *and* JOHANNES

108 LAMOTT, ANNE *and* SAM

118 LEFFALL, RUTH M. *and* LᴬSALLE D. III

68 LEVITAS, FERA *and* MITCHEL

56 LORD, BETTE BAO *and* WINSTON BAO

84 MᶜEVOY, NAN TUCKER *and* NION T.

54 MORAND, SIMONE, *and* YVES PETIT DE VOIZE

114 NAKAMURA, SUSAN *and* YUGO

102 OWINGS, NATHANIEL OTIS, *and* EMILY OTIS BARNES

52 PASTERNAK, BELLA, STEVEN, ALVIN, *and* JERALD

126 PASTERNAK, SUE *and* URI

54 PETIT DE VOIZE, YVES, *and* SIMONE MORAND

90 ROTHOLZ, BAILEN, DAVID ELI, DANIEL, *and* SUSAN ROTHOLZ

12 RYKIEL, SONIA *and* JEAN-PHILIPPE

18 SALMON, SYLVIA IVY BRUDENELL *and* COLIN

44 SANTOS, JOHN, DOROTHEA WILKINSON, *and* FRANCO BARONE

16 SAUMAREZ SMITH, ROMILLY *and* OTTO

48 SHANNON, MICHAEL, *and* MARY STRUDWICK

11 SHAWN, HAROLD, *and* JAMAICA KINCAID

38 SHERMAN, EDITTA, BRADLEY, *and* LLOYD

112 SPIELBERG, STEVEN, *and* LEAH ADLER

36 STRAUS, DOROTHEA *and* ROGER W. III

48 STRUDWICK, MARY, *and* MICHAEL SHANNON

34 STYRON, ROSE *and* TOM

110 SUZUKI, RITSUKO, YUTA, *and* DAISUKE

106 SWENTZELL, ROXANNE *and* PORTER PAUL YORK

30 TRUJILLO, CARMELITA *and* DOMINIC

28 TUAL, DENISE, JACQUES, *and* CHRISTIAN

94 TUROW, RITA *and* SCOTT

26 TYNAN, KATHLEEN *and* MATTHEW

46 WEST, MILDRED *and* ARCHIE

44 WILKINSON, DOROTHEA, JOHN SANTOS, *and* FRANCO BARONE

88 WILLIAMS, LAURIE *and* ROBIN

42 WINICK, FLORENCE *and* EUGENE

40 ZAH, MAE *and* PETERSON

THIS BOOK WAS DESIGNED BY JILLY SIMONS WITH DENISE HECKMAN AT CONCRETE, CHICAGO.
THE TEXT WAS SET IN SCALA, DESIGNED BY MARTIN MAJOOR IN 1991 AND NEWS GOTHIC, DESIGNED BY M. F. BENTON IN 1908.
THIS BOOK WAS PRINTED IN THE UNITED STATES OF AMERICA USING THE FULTONE PROCESS II
AND A 300-LINE SCREEN AT GARDNER LITHOGRAPH, BUENA PARK, CALIFORNIA.